Helen Levitt · In the Street

A LYNDHURST BOOK

PUBLISHED BY DUKE UNIVERSITY PRESS

IN ASSOCIATION WITH THE

Center for Documentary Studies

Art Center College Library
1700 Lida Street
Pasadena, CA 91103

ART CENTER COLLEGE OF DESIGN

3 3220 00303 8432

HELEN LEVITT

IN THE STREET

CHALK DRAWINGS AND MESSAGES

NEW YORK CITY

1938 – 1948

*

WITH AN ESSAY BY

ROBERT COLES

A LYNDHURST BOOK
PUBLISHED BY DUKE UNIVERSITY PRESS
IN ASSOCIATION WITH THE
CENTER FOR DOCUMENTARY STUDIES
DURHAM • NORTH CAROLINA

© 1965, 1981, 1986, 1987 HELEN LEVITT

TEXT © 1987 ROBERT COLES

ALL RIGHTS RESERVED

*

LIBRARY OF CONGRESS CATALOGING-IN-PUBLICATION DATA

Levitt, Helen.

In the street.

 1. Photography of children. I. Coles, Robert.

II. Harris, Alex. III. Hoshino, Marvin.

IV. Duke University. Center for Documentary

Photography. V. International Center of

Photography. VI. Title.

TR681.C5L48 1987 779'.25'0924 86-29367

ISBN 0-8223-0728-6

ISBN 0-8223-0771-5 (pbk.)

*

DUKE UNIVERSITY PRESS
BOX 90660
DURHAM, NORTH CAROLINA 27708-0660

Lyndhurst Books publish works of creative exploration by writers and photographers who convey new ways of seeing and understanding human experience in all its diversity – books that tell stories, challenge our assumptions, awaken our social conscience, and connect life, learning, and art. These publications have been made possible by the generous support of the Lyndhurst Foundation.

CENTER FOR DOCUMENTARY STUDIES AT DUKE UNIVERSITY
1317 WEST PETTIGREW STREET
DURHAM, NORTH CAROLINA 27705
www.duke.edu/cds

Third printing, 2002

Robert Coles: Children as Visionaries

"Do not fail to see how far ahead children can see, but only some of them, and they only sometimes, and for certain reasons which it is your task to comprehend." I remember hearing and taping those words years ago at a clinical conference of child psychoanalysts, chaired by Anna Freud, whom I was lucky, indeed, to know. I remember, too, being struck by that particular statement, her way of putting things – slightly awkward, rather firm and insistent, with a touch of both the poetic and the morally awake in her remarks. She was never one to put herself far out on any limb; she knew how cautiously qualifying any generalization about children ought be – if the speaker or writer cares about accuracy or a decent respect for the complexity of things. Still, she was mentioning a farsightedness in children which I found intriguing – given the awareness all of us had in that room with respect to the usual immediacy that characterizes the lives of the young: their contingent responsiveness to the here and now.

When the conference was almost over, she allowed herself a few summary remarks, and again she made reference to vision: "A child who seems confined by the world can't escape, usually – but *can* look around all possible corners; or the child can try to change the world by seeing it differently. Our eyes lend themselves to our wishes and our conflicts. We only truly notice a small amount of what is there, to be noticed – and so children, like the rest of us, pay attention to what, for one reason or another, serves their purposes."

She would have been the last one to claim originality and sweeping significance for such remarks, and yet any discussion of children's art – what they draw or paint on paper, or canvases, or on the walls of buildings, or with chalk on sidewalks or streets, or, yes, on the plain dirt and mud of obscure villages in distant nations – has to begin with an acknowledgment such as Anna Freud made: there are in each of us certain private reasons for noticing *this*, for summoning *that*, for wanting to see one aspect of reality given a degree of permanence and for having no such interest that another aspect of that reality should have any visual life whatsoever. This interior and idiosyncratic or personal element in the visionary life of children (not to mention the rest of us) is especially important to emphasize in connection with the street pictures of New York neighborhoods which Helen Levitt captured for us in the 1940s – lest we let ourselves be launched, all too readily, on a sociological and anthropological trek.

We'll never be able to return to those streets, meet those children, view their chalky efforts, ask about them directly or indirectly – hence the temptation of the so-called "sociocultural" approach, with all its beckoning if not satisfying generalizations. Yet, in each child there are unforgettable remembered experiences which both embrace and do battle with what gets called social customs or cultural traditions and styles.

Who will ever know, for instance, what the heart, the valentine on the forehead of the particular boy Helen Levitt glimpsed and recorded meant to him – what sly or flagrant passion, what hidden or dramatically avowed love it was meant to announce to the rest of the world? The boy bears a signal, a suggestive one, indeed – and we, witnesses decades later, are left to surmise: a radiant embrace of another, or a mark of burning frustration? Similarly with the messages – literal or pictorial and metaphoric – which these children once upon a time chose to render through the medium of chalk applied to asphalt – a vulnerable but quite immediate and assertive reality. "A 'decetive' lives here," we are told, but whether the artist and the beholder are to register satisfaction and relief, or be warned strenuously is a matter for conjecture: maybe both. Why Rhoda's blonde hair is so "nice," possesses such a "beautiful shade," is also an unanswerable question – a child's subjectivity that will never be fathomed by anyone, though the relative paucity of blondes on those Spanish Harlem blocks prompts speculation, no doubt, in some of us today, as we think of the hold of the exotic on all children, not to mention the sad awe (or envy) the weak sometimes feel toward those who seem to be on top of the world.

It is right (but too easy) to emphasize the temporal and cultural – the passing nature of childhood habits: their response to what prevails as a given moment's

mysteriously arrived kick or fad or seemingly un-challengable mandate, soon enough to vanish alto-gether. When I have heard elderly people in Boston or elsewhere wonder why boys and girls no longer scrawl with chalk on sidewalks the way they used to do, I have heard in their words (and sighs) the expressed uncertainty and perplexity, the aching wonder, we all feel as we contemplate concretely such abstractions as "cultural change" or "social customs" in their wide variety, their onset and demise.

In the Spanish Harlem of the 1940s, one gathers, there were no terrible gang wars, or at least no evidence of them on the streets Helen Levitt visited in her eye-opening walking, glimpsing, documentary search. These seem to be streets of gentility and civil-ity – a slum, perhaps, but also a place of camaraderie, familiarity: a block, meaning a place numerous fami-lies consider (in heart as well as mind) common ground. When the children themselves appear, they seem relaxed and trusting – their access to the street's asphalt assured and in no jeopardy. They have felt im-pelled to make their various marks upon a given world, and seem sure as can be that others will have the time and inclination to pay heed.

This was a world that ran by another clock than the one we know now in Harlem or in the fancy blocks to its south – a world whose children still had some visual independence, some keen-eyed interest in laying pic-torial claim to the world around them. In contrast, today's children are not only fast-moving but all too still as well, spellbound by the countless television sets which command their constant attention.

In New York now there are gangs, yes, but drugs and sitcoms do their dampening deterrence, keep many cats cool, thoroughly glazed or relatively energetic, often enough, in the saddest or most terrifying ways. There are, to be sure, others – wonderfully alert, knowing, thoughtful boys and girls who don't deserve the blanket defamatory certainties of outsiders with fluent and self-important pens, eager to generalize. Still, I have not seen scenes such as Helen Levitt offers in my wandering through America's city streets twenty and thirty and forty years after these were taken. They offer, then, a look backward – though they also are timeless in certain respects. For children will never really stop being tempted by their imaginative fac-ulties to show and tell – to let others see what they find themselves conceiving in thought and fantasy and dream.

When I decided to use the title of "Children as Vi-sionaries" for my text, I had in mind a cognitive or literal aspect to their seeing (and artistically represen-tational) life as well as a moral and existential side, namely, how they use what they manage to see reflec-tively. There is no question that children, as they grow, are constantly taking note of more and more, widen-ing the arc of their visual interests, and, too, focusing their attention more finely as well as expanding its range. "Look what I saw that I missed before, com-pletely," I once heard from a child – as he pointed to a bunch of yellow daisies growing near the hospital grounds. We'd taken a walk, rather than sit in my out-patient clinic office. He wasn't trying to "evade" the discussions he knew we ought to have – and he wanted to have. He was, actually, letting me know that he was increasingly able to pay close attention, catch exact sight of what he previously ignored, and use what he saw imaginatively.

Of course, children not only envision a particular world, analyze its aspects, figure its function; they also use its various concrete and potentially symbolic ele-ments in order to answer those universal questions which it is in our nature as human beings to pose: what matters, and why, and how will my life unfold, and to what purpose? There is no point in romanticiz-ing the mental life of children – turning them into philosopher-kings and queens, whose words and thoughts (and artistic productions) we ignore at our own peril, and, yes, ignore out of our fearful aware-ness, commonly, that their truth is somehow more than we can tolerate. This notion of childhood per-ception and reflection does scant justice to the limits of awareness and knowledge in the young, and the hap-hazard nature of much of their early cognitive life – to the struggles they have to wage if they are to be able to sift and sort with increasing discernment. True, from Jesus of Nazareth to Rousseau (and in our time, among some educational critics) the "innocence" of children, their openness to experience, their un-blemished moral virtues have been stressed – so often as a means of condemning this devilishly corrupt world of their elders, of ours. But there is another side

to children – to all of us: self-centeredness, impulsive behavior, a demanding insistence upon getting one's way, naiveté, gullibility, and so on, all of which one mentions not in order to be cynical or with any animus, but in order to insist upon sentimentality as a hazard for those of us who work with children, enjoy doing so, feel we learn a lot from them, and are proud to tell others what we have learned, indeed, make a career of such an exercise. Yes, it is a mistake to deny children lust, avarice, truculence, egoism – and there are hints of all these in the street drawings, no matter the quick delight we take upon a first glance. To patronize children with *only* that delight is to miss the point of their humanity. They, too, want to look "pretty" and may not feel as "pretty" as they would hope; they, too, feel surges of envy (with respect to others who are conventionally "attractive") and deal with such an emotion by imagining themselves as, perhaps, looking different; they, too, know surges of annoyance, irritability, anger, and can picture themselves (in their heads, and with chalk or crayons or paint) pulling a pistol, aiming it at someone, anyone, and firing away; they, too, know love, know the possessiveness and jealousy that love can generate, as well as the intense eagerness to embrace and be embraced, as these chalk sketches rather vividly attest.

Nor ought we neglect another aspect of the visionary life of children – their interest in what seems attractive, if not entrancing. They are not psychological puppets or culture-bound automatons or morally obsessed – even though the unconscious works steadily away as they go through childhood, and even though all societies press upon the young an enormous number of constraints, but also various opportunities or leeways for expression, and even though they most definitely do wonder long and hard about what is right and wrong, and why this world works one way, and not another.

As for a child (to mention one of Helen Levitt's photographs) who takes note of a billboard with its mid-twentieth-century allure, its Hollywood glamour, its image of seductive show – and then tries to respond, to copy what is advertised as beautiful or to declare an affinity for that beauty, a hope with regard to oneself as a repository of it – such a boy or girl is surely one of us, as susceptible as so many of us are to the "picture" a given culture emphasizes. We absorb those "pictures" all the time, and they affect our sense of ourselves (and our judgment of others) more than we care to realize.

A special favorite of mine is the depiction of a sleek and quite prominently situated train, which soars across the American land, a majestic counterpoint to our forests and mountains, a mid-1940s monument to our technological achievement, a testimony, maybe, to a child's notion of transcendence: the sparkling sun itself looms close above the train's center. Today, of course, a child might give us a plane or – who knows? – a spaceship, unless he or she lived in a part of the world where a train is still a notable miracle, and, too, a repository of so many dreams: the means by which a child might be transported elsewhere, to nature's untarnished beauty (as opposed to urban reality). These photographs, with their visual offerings, with their chronicle of earthy, blunt, and ever so instructive language – the tough and touching words tether, as it were, some of the almost ethereal pictures – are part of the long and highly charged street tradition of New York.

So did these children take to the streets. They played with the water of hydrants, scanned the margins of this or that "movie picture theater," sat on the steps of those old brownstones, their faded elegance awaiting, perhaps, an appreciative suitor. They squabbled and cursed and swore and shouted and screamed and sang and whispered love messages and dreamed, always dreamed: to be a detective or a wildly successful gangster who never gets caught; to be liked by everyone (especially the most handsome boy, the prettiest, most charming girl); to be feared by all but one's friends, one's accomplices; to rise and rise and be rich and celebrated and irresistible; to have lots of tasty food for the palate and all the soft drinks the throat can want to swallow; to find that proverbial place in the sun, to catch a piece of that moon, even if that moon was weary, no doubt, of being asked for this, of hearing appeals in song after song. These children wanted what we all want – to be, my life ahead, may it amount to something, *please*. Let us see what they saw, what Helen Levitt gives us to see – ourselves in yet another "them," a "they" who are, finally, "us": earnest, wondering, questioning fellow sojourners on this earth.

7

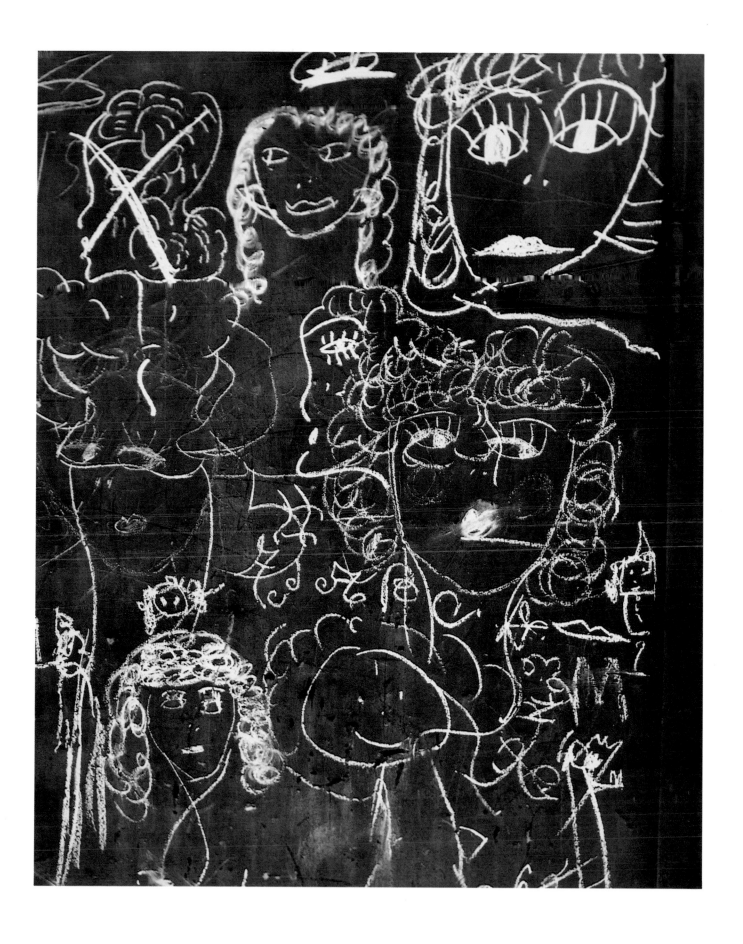

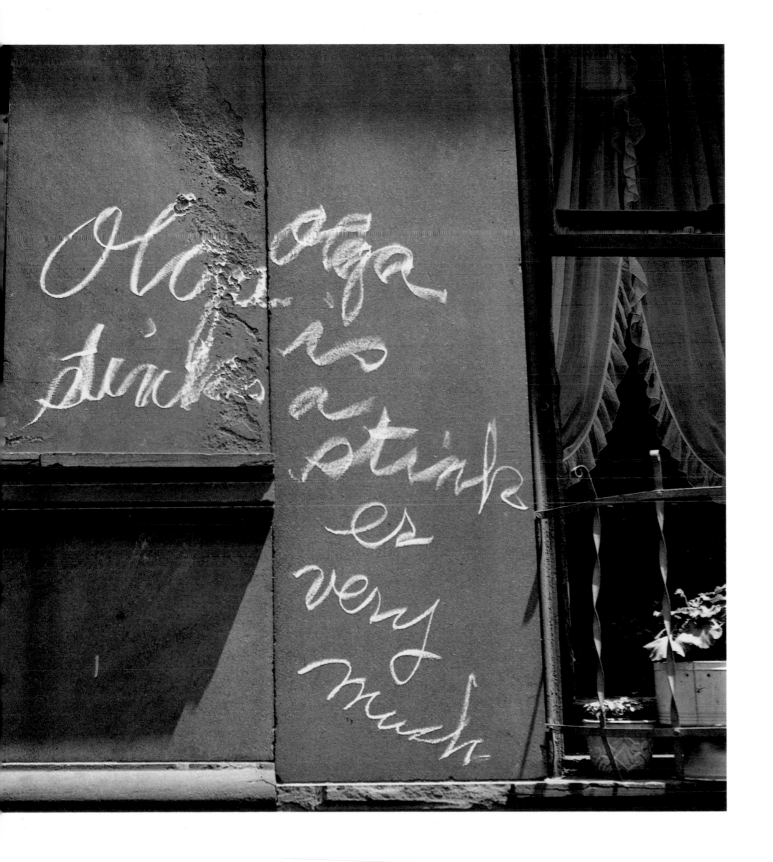

Art Center College Library
1700 Lida Street
Pasadena, CA 91103

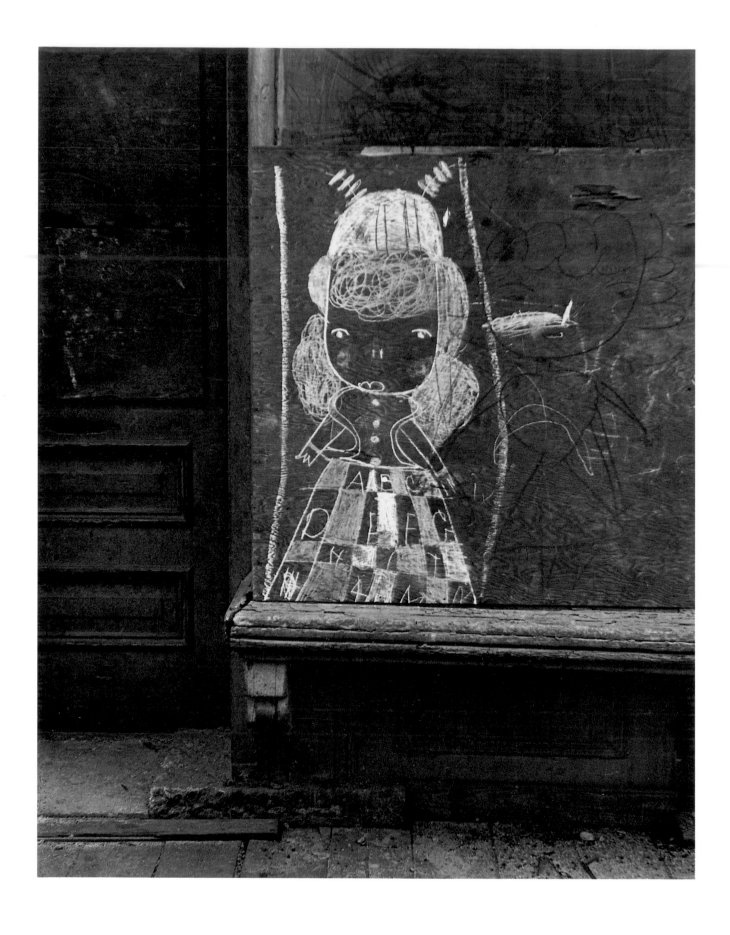

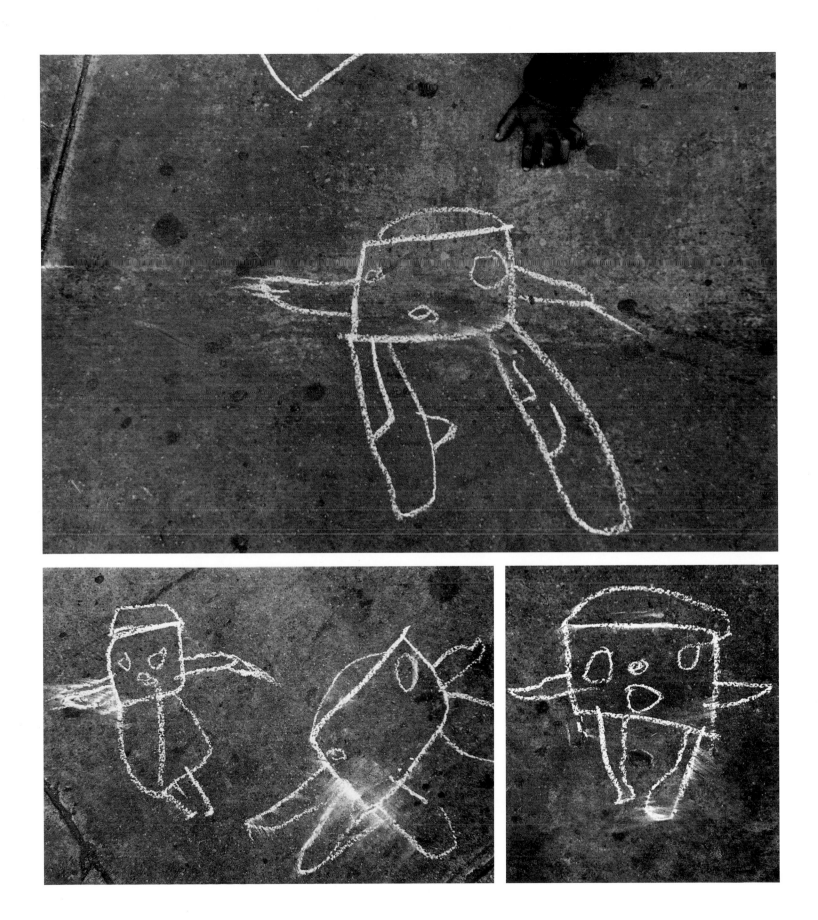

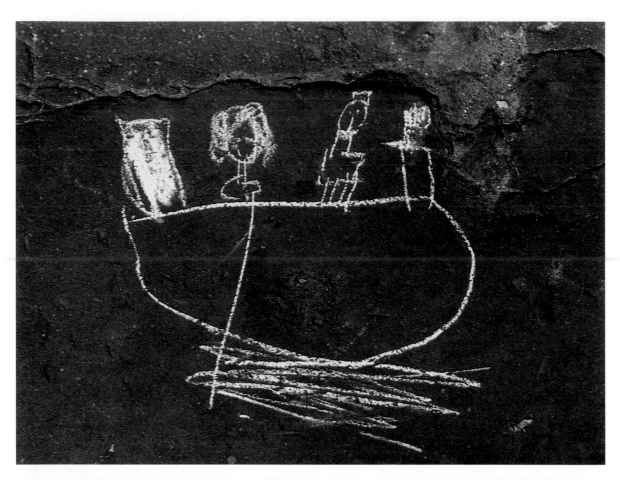

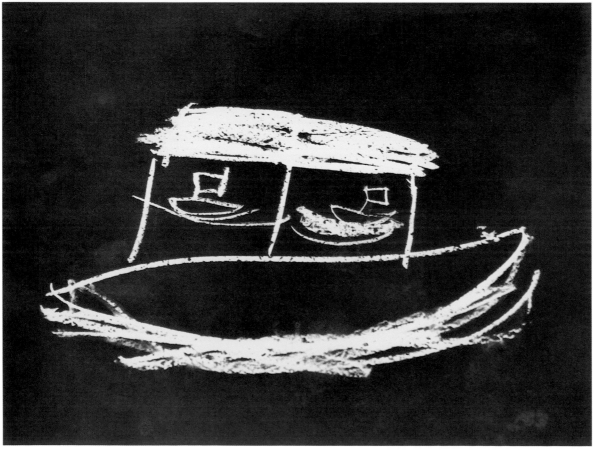

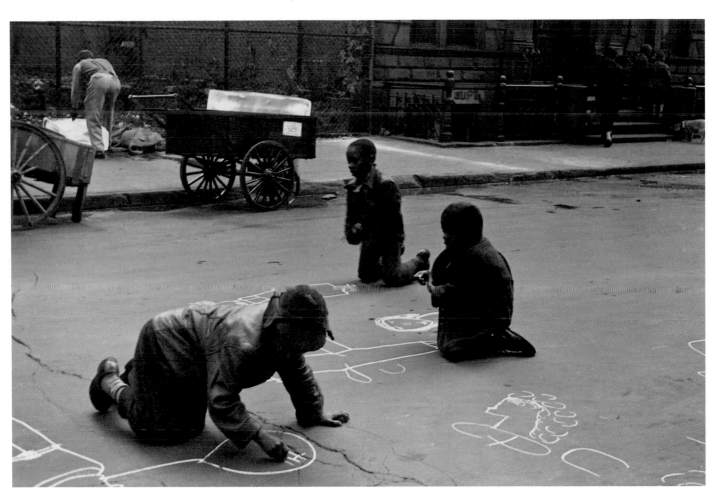

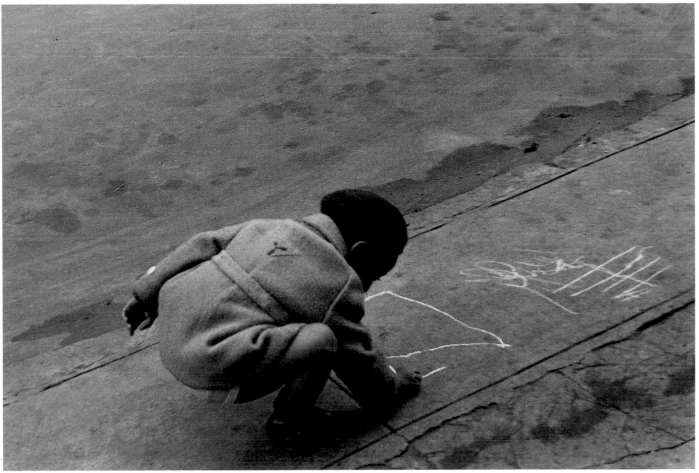

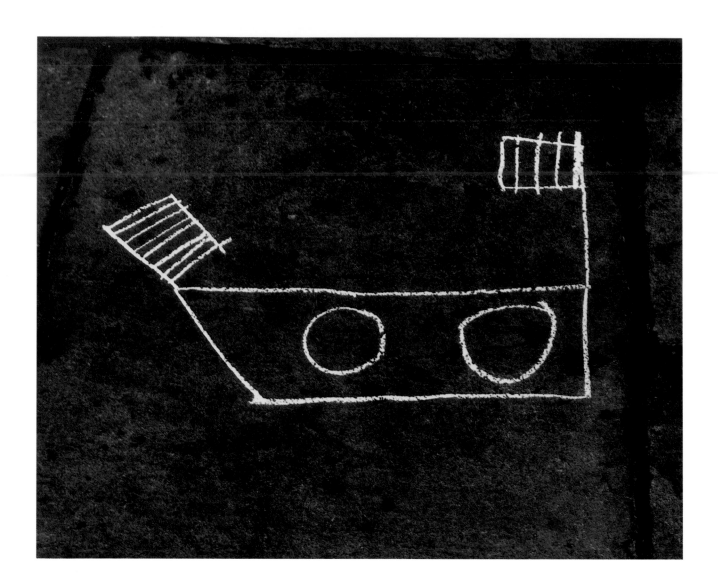

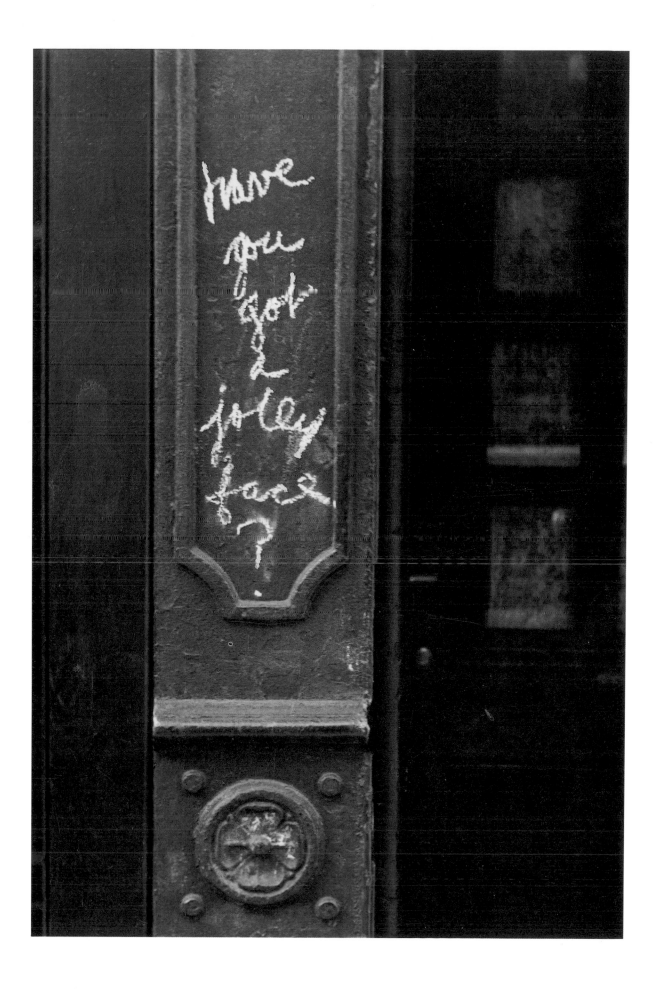

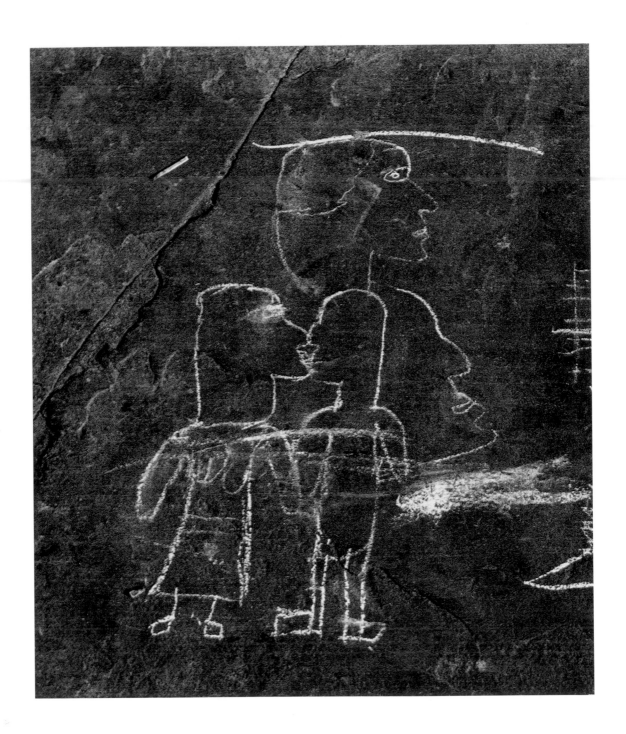

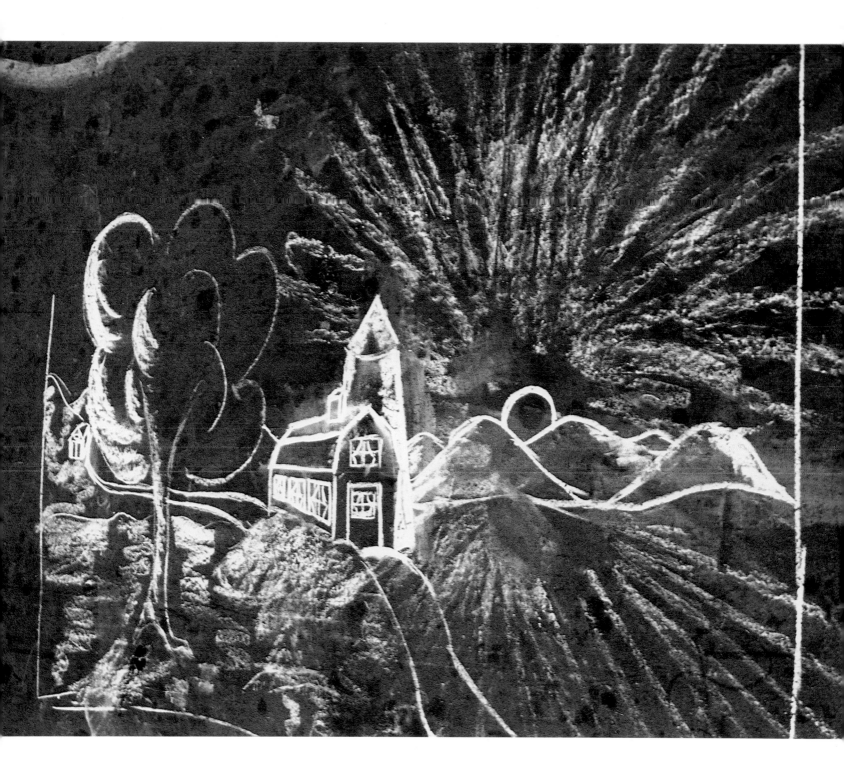

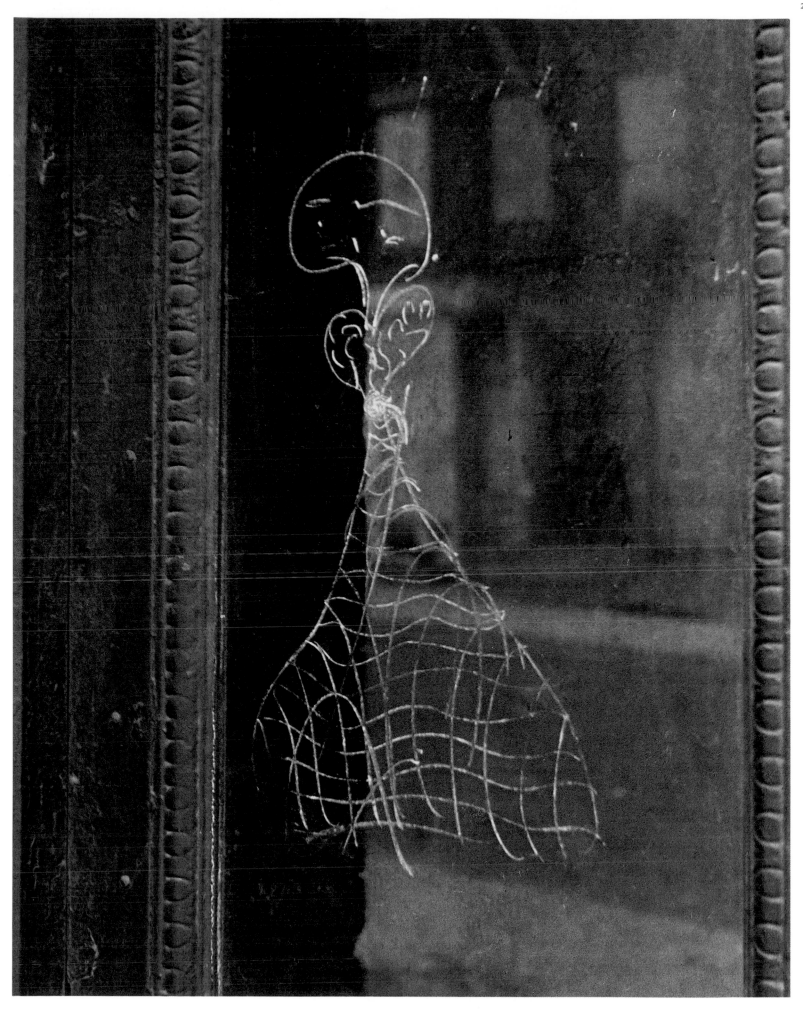

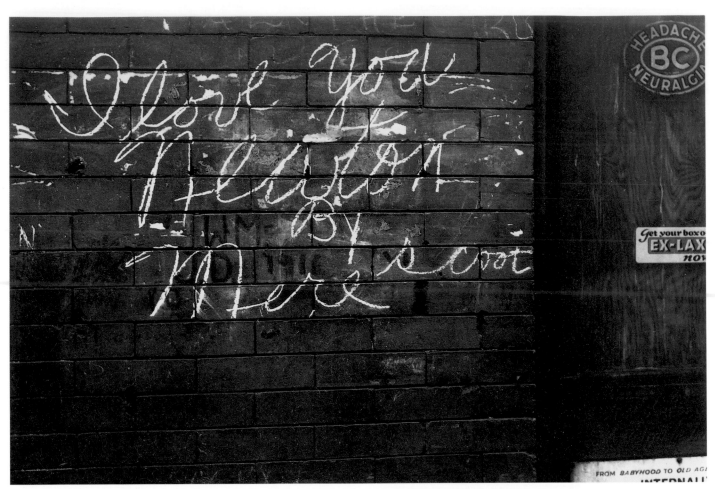

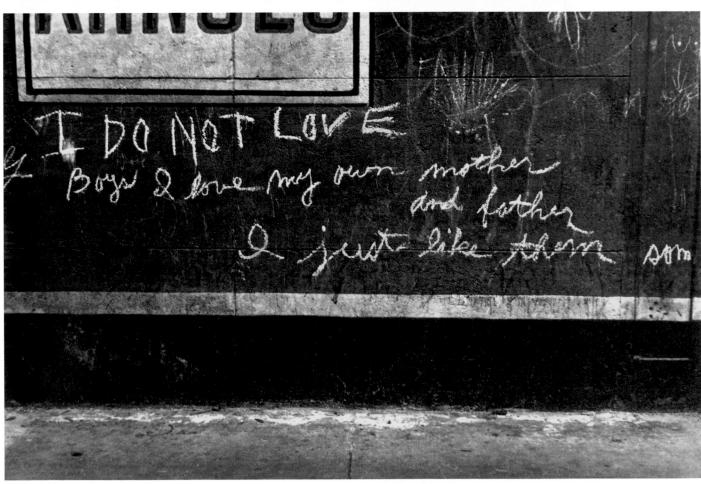

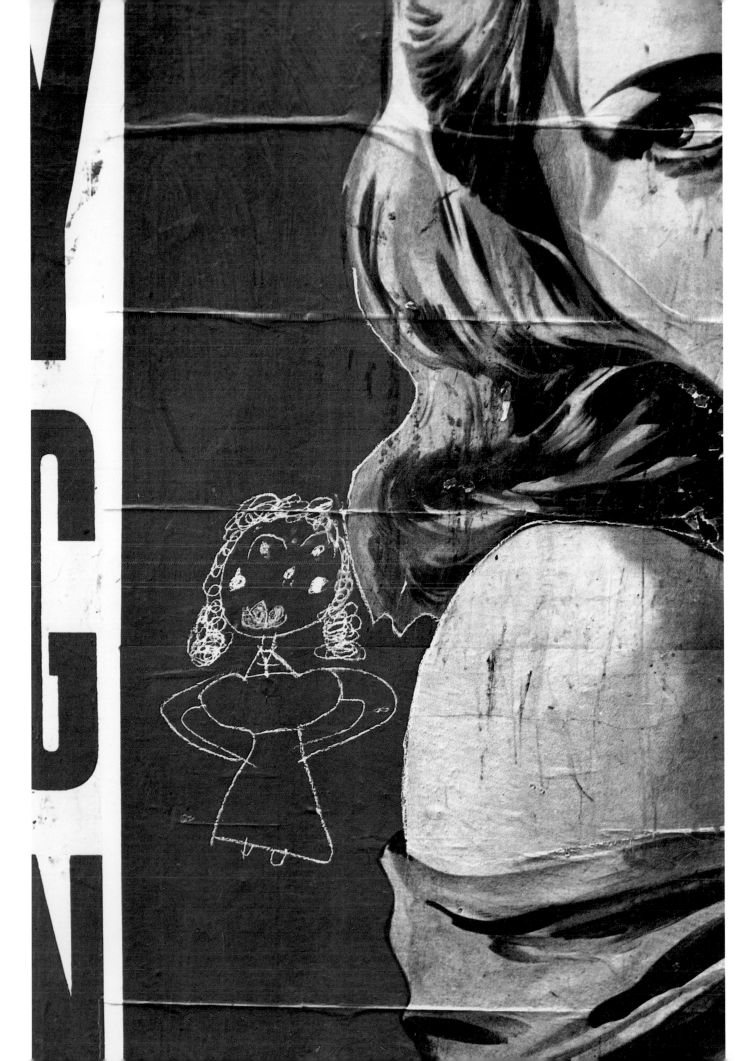

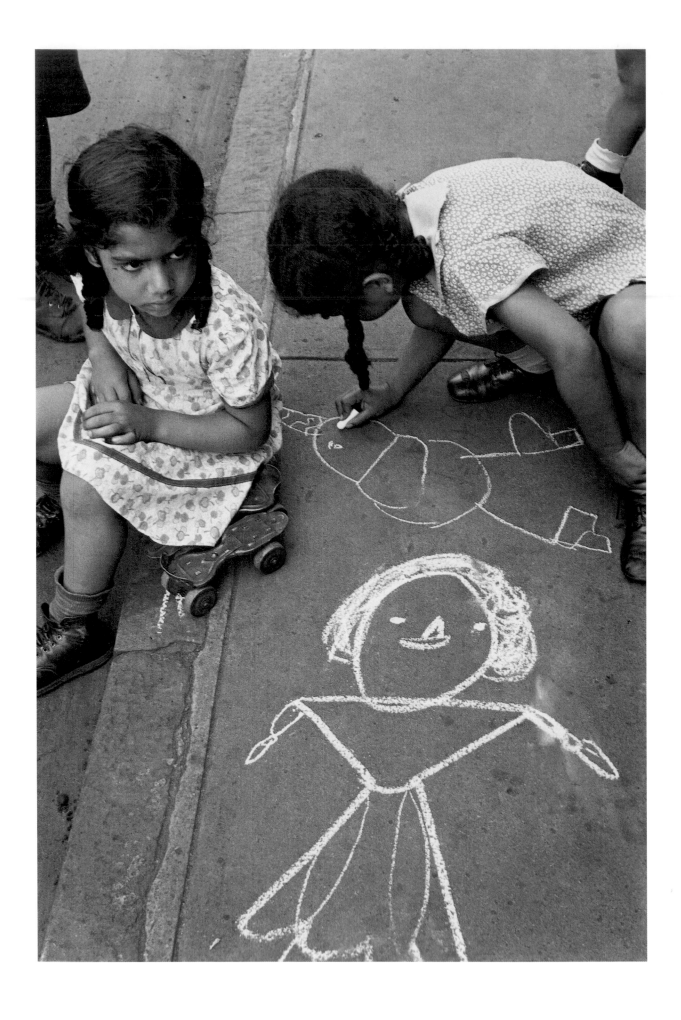

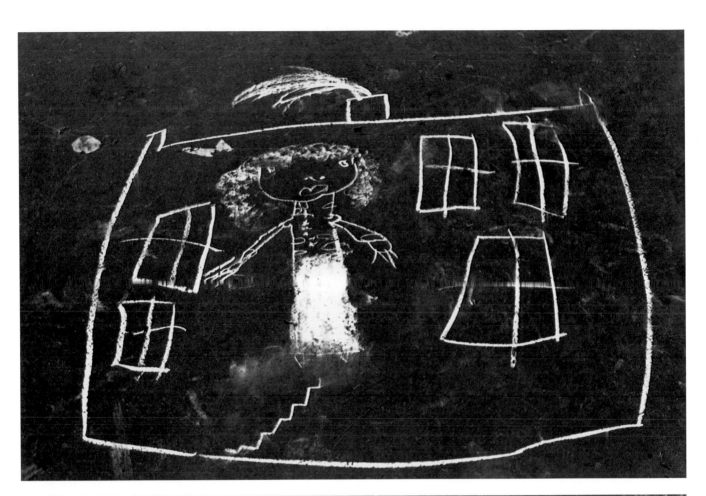

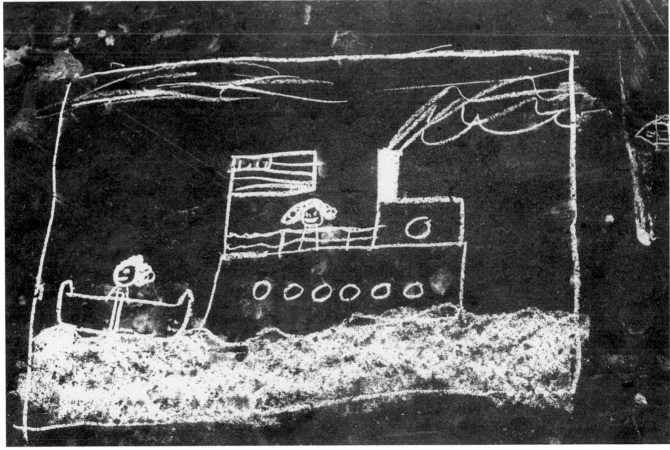

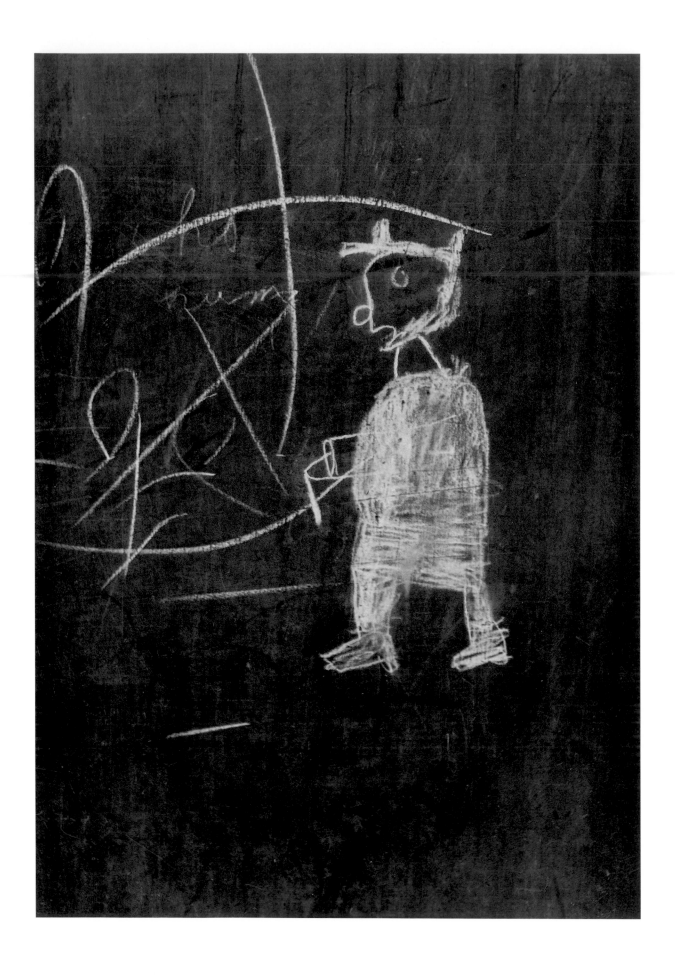

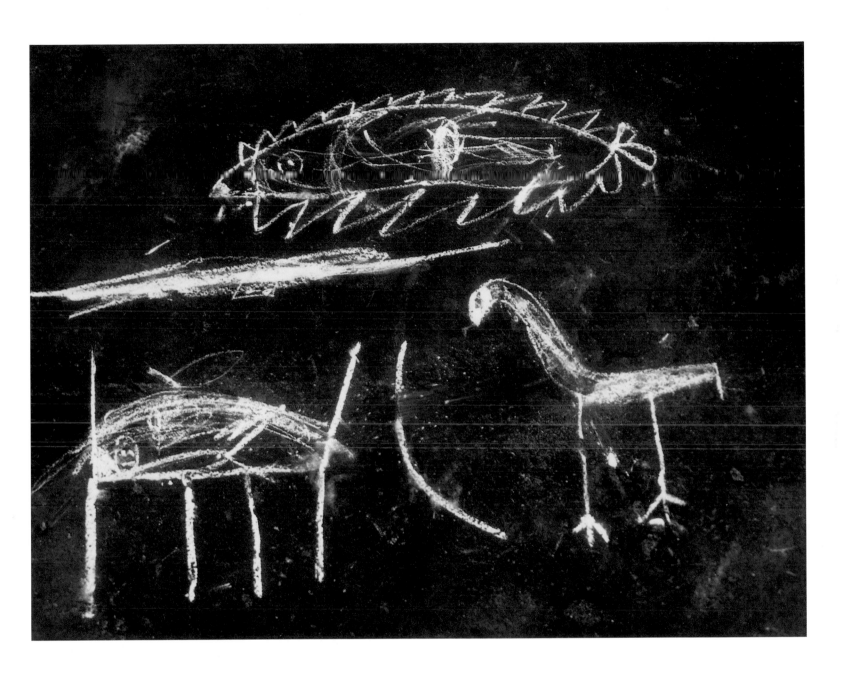

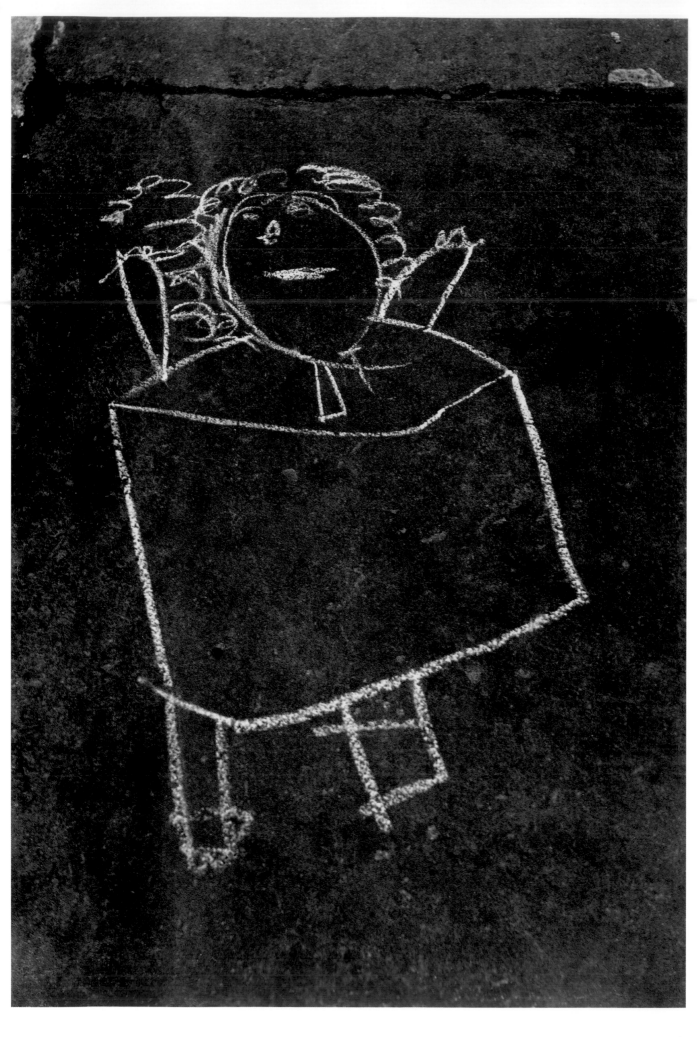

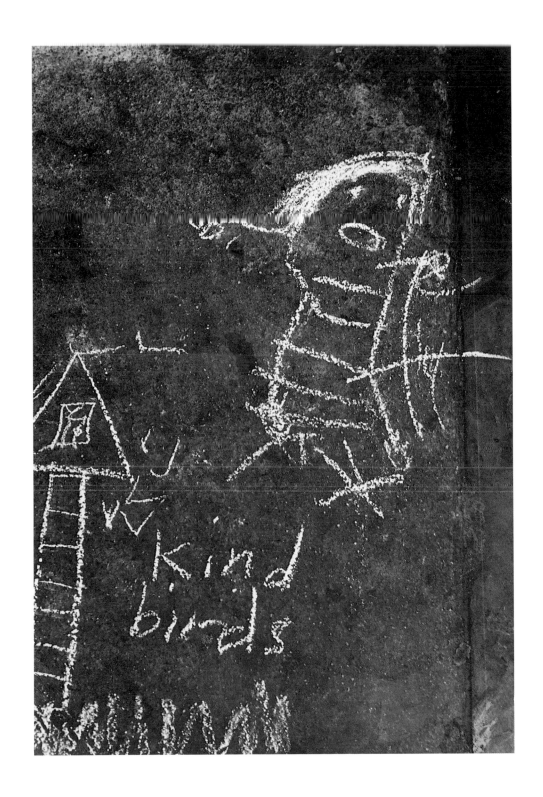

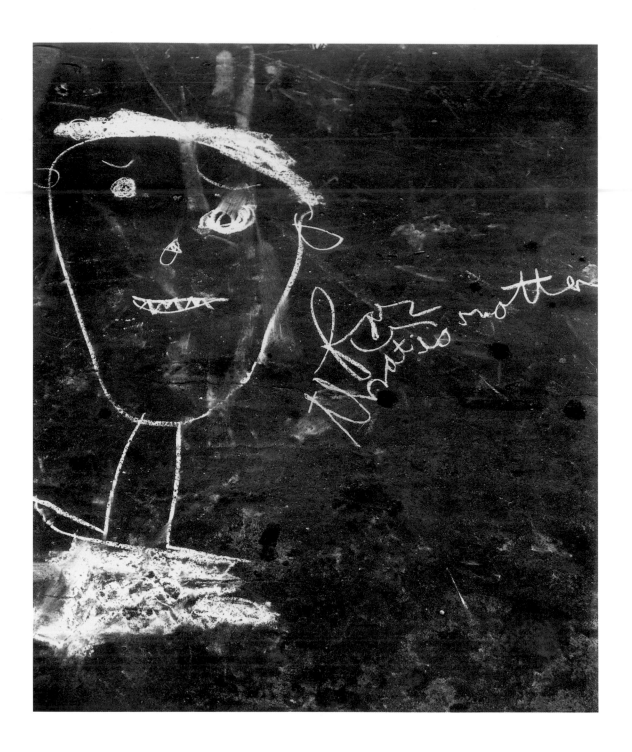

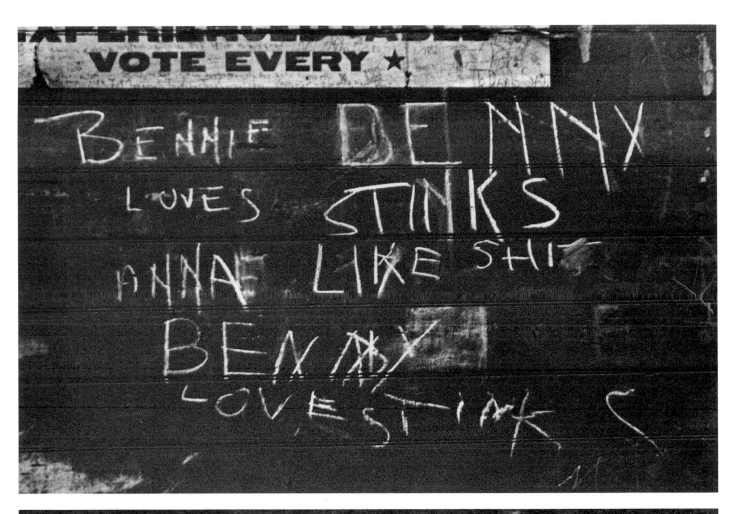

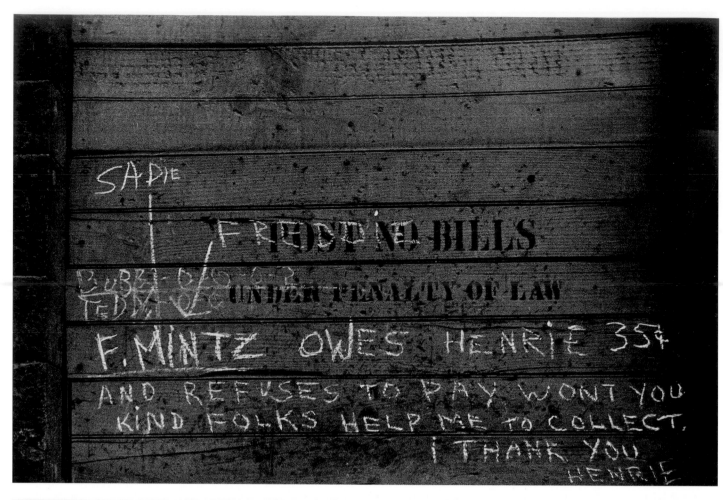

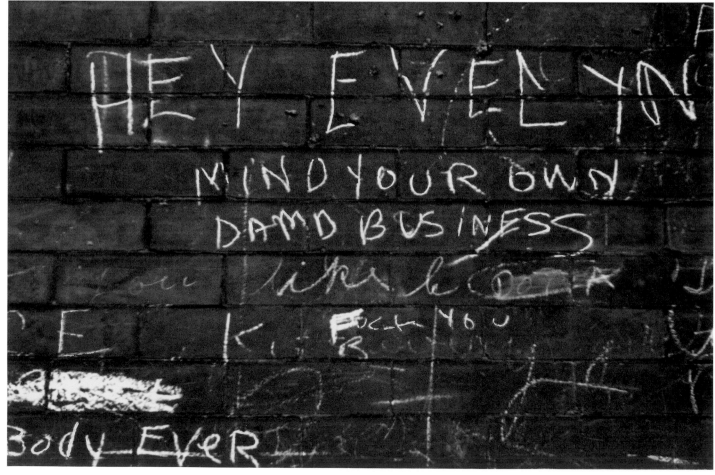

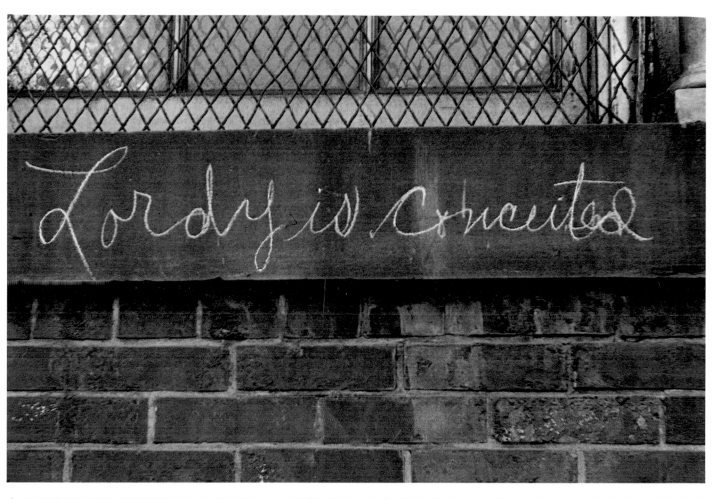

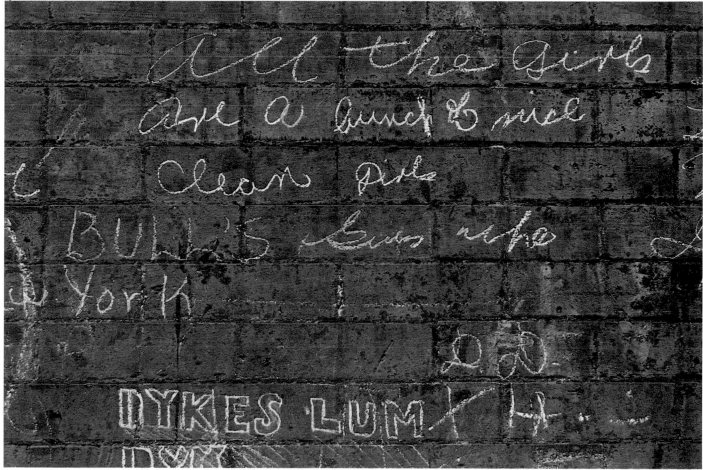

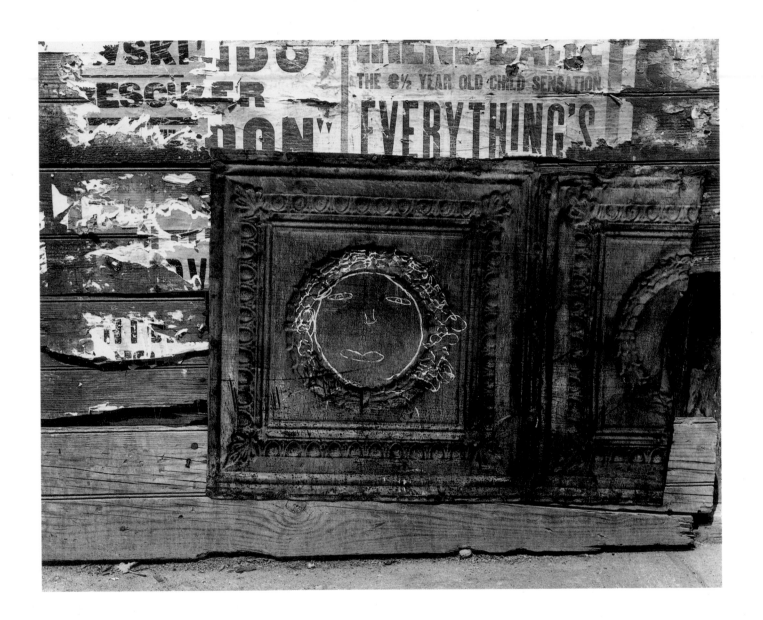

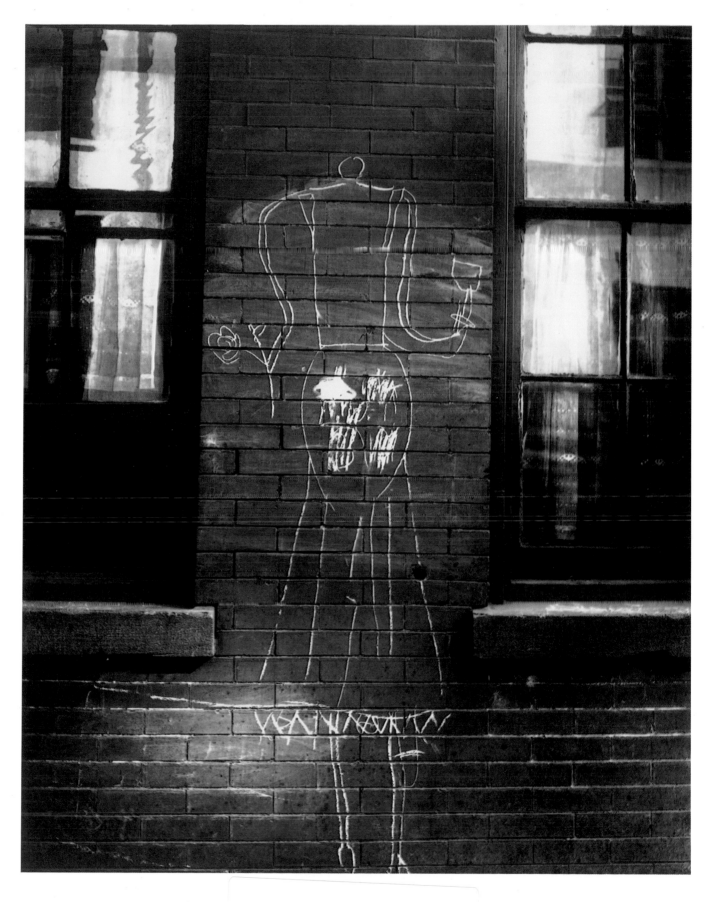

Art Center College Library
1700 Lida Street
Pasadena, CA 91103

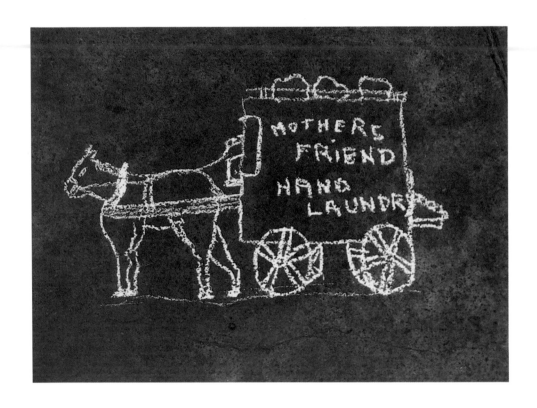

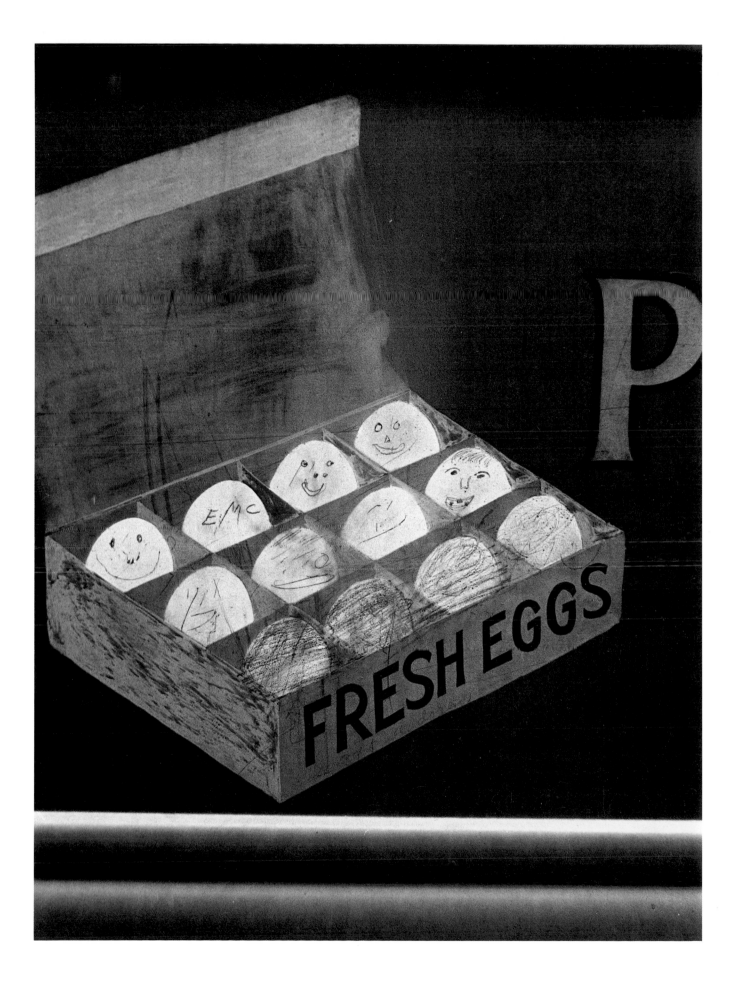

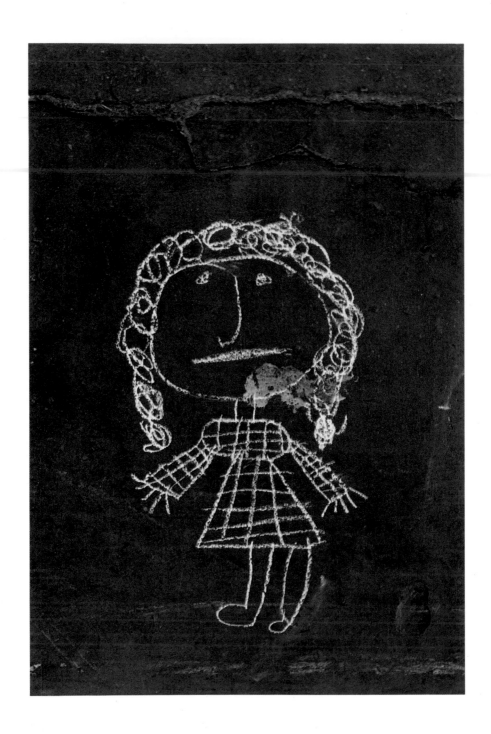

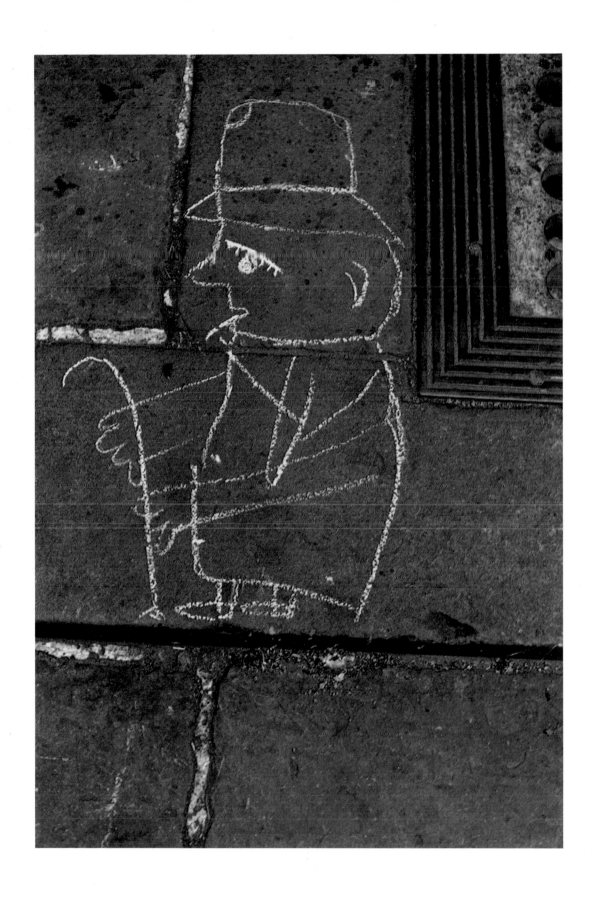

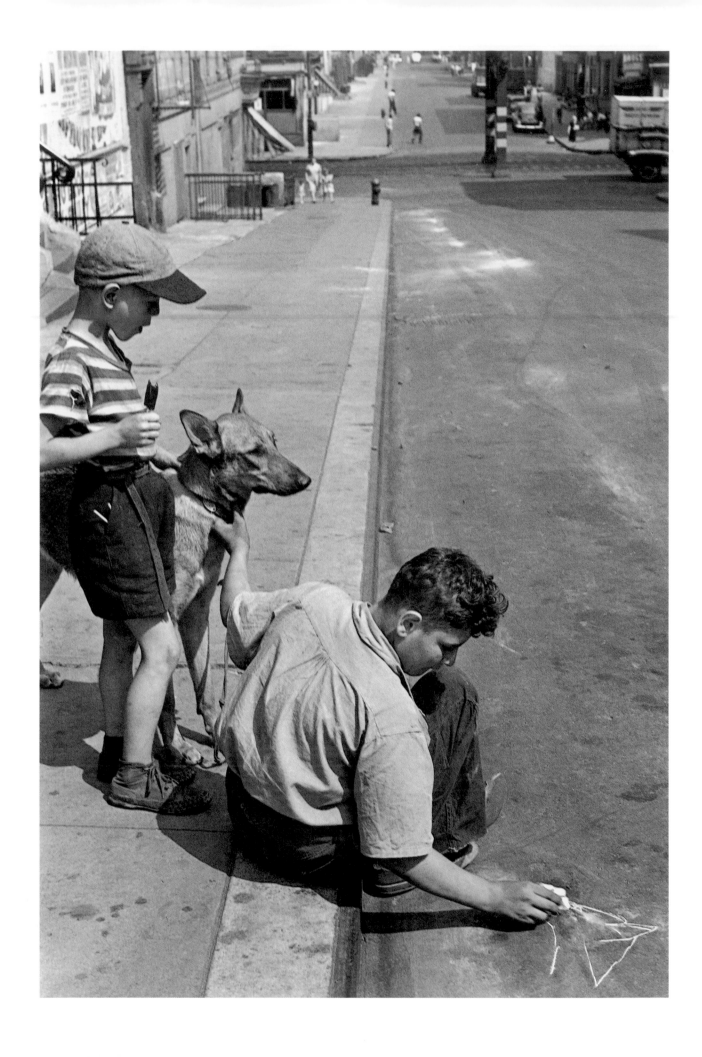

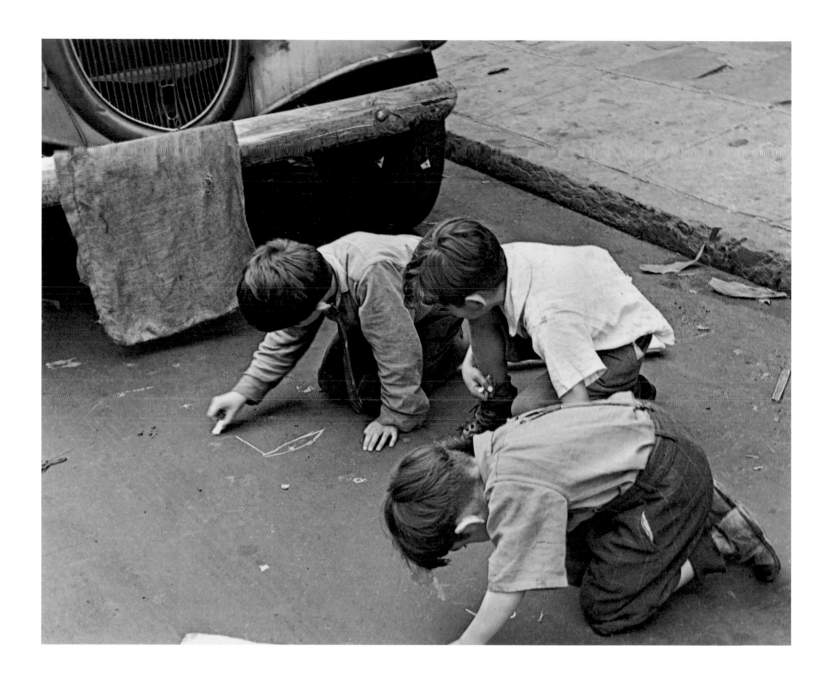

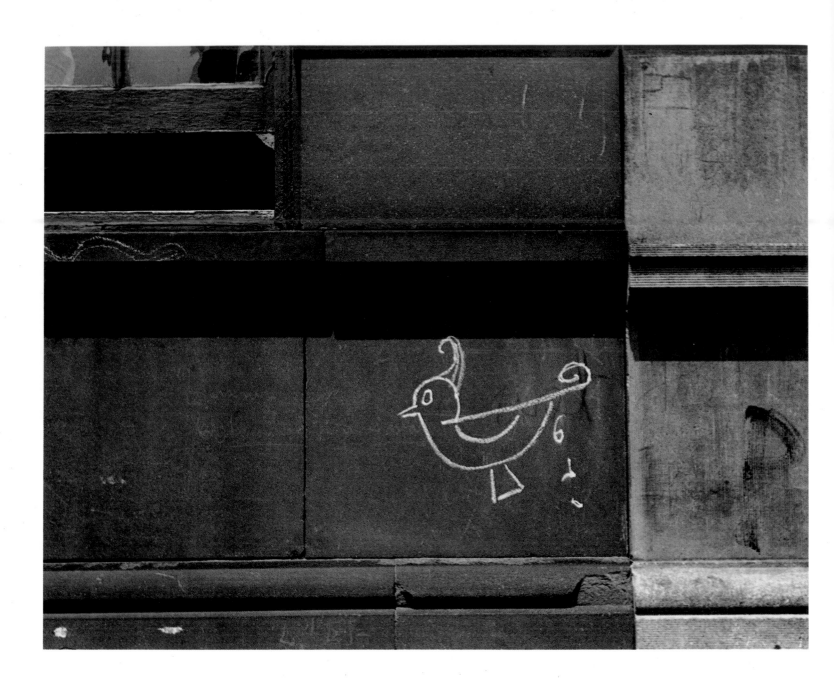

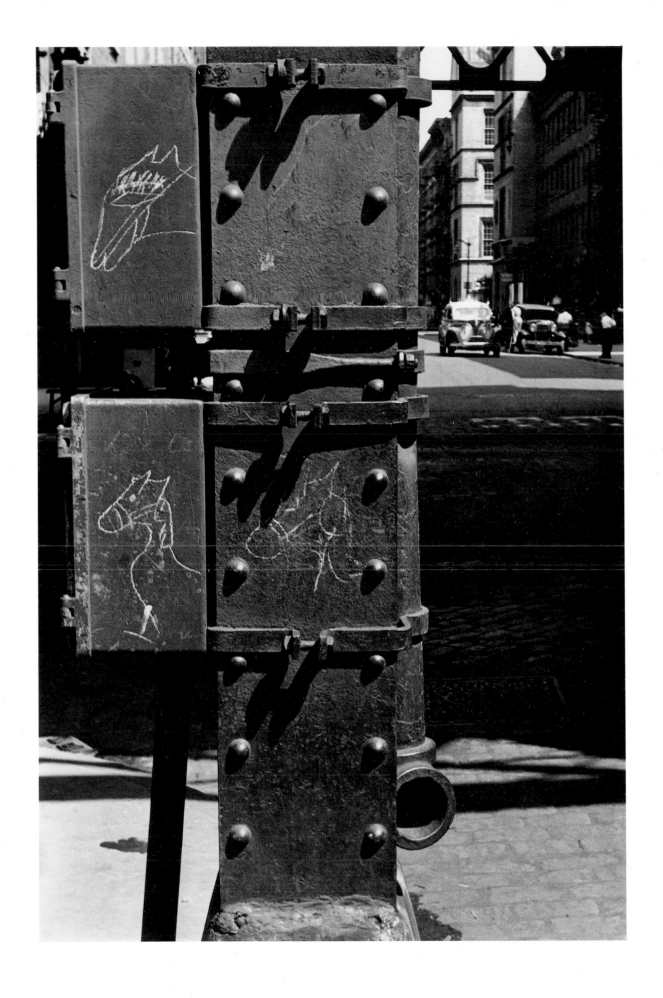

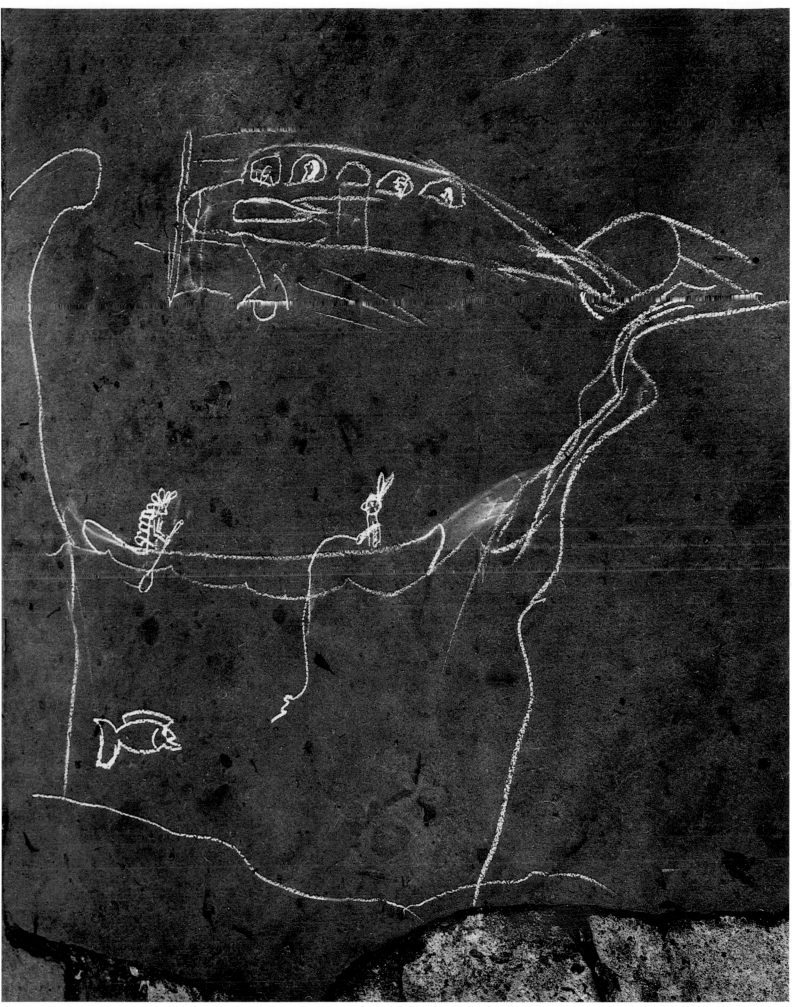

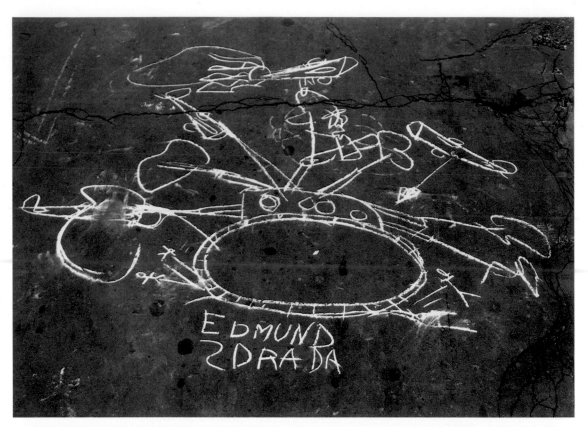

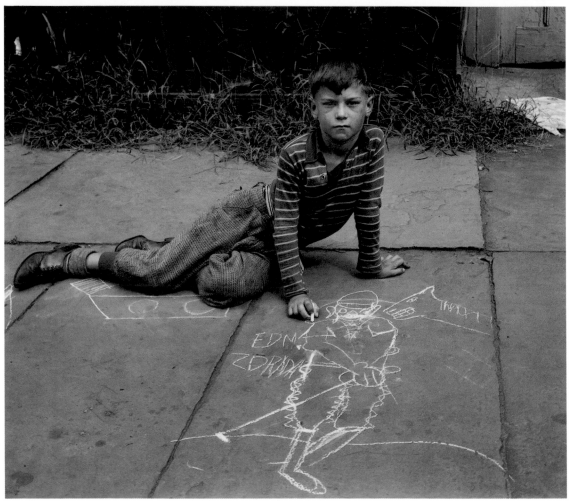

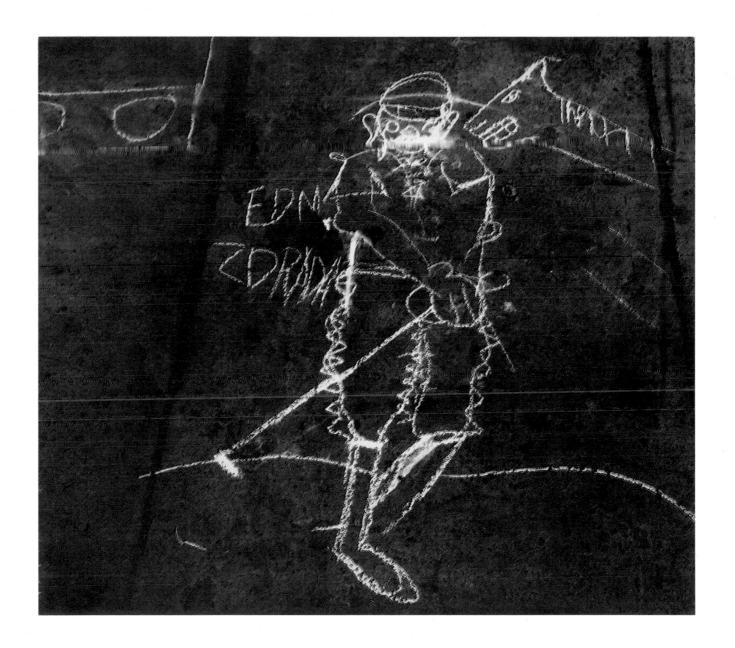

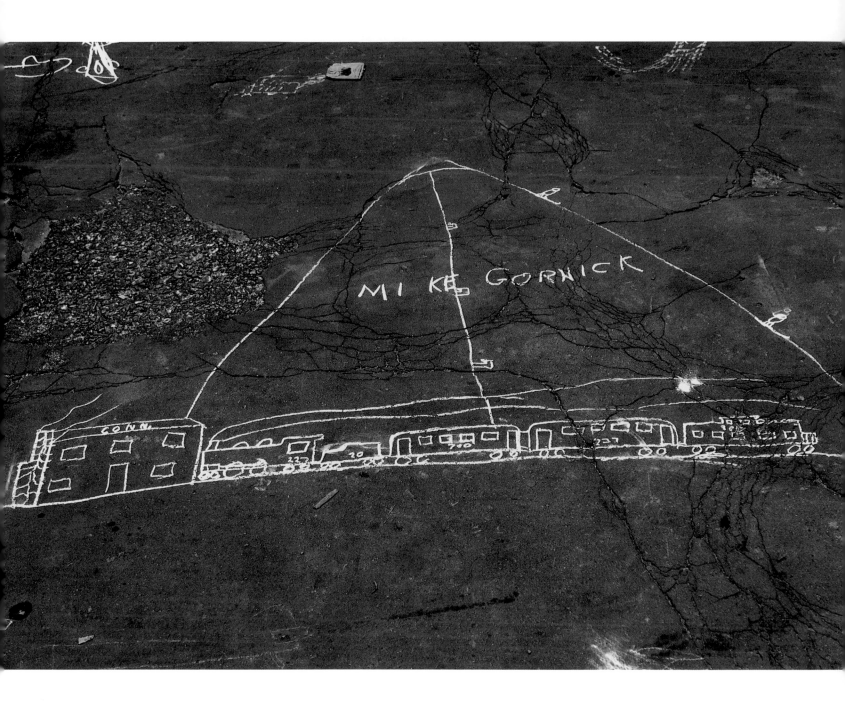

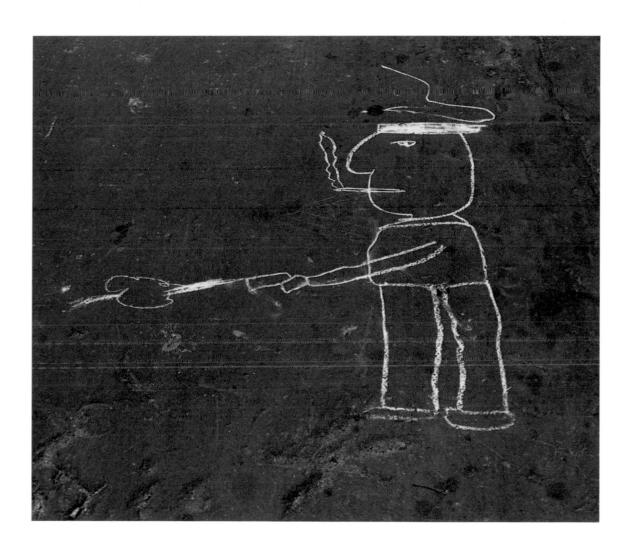

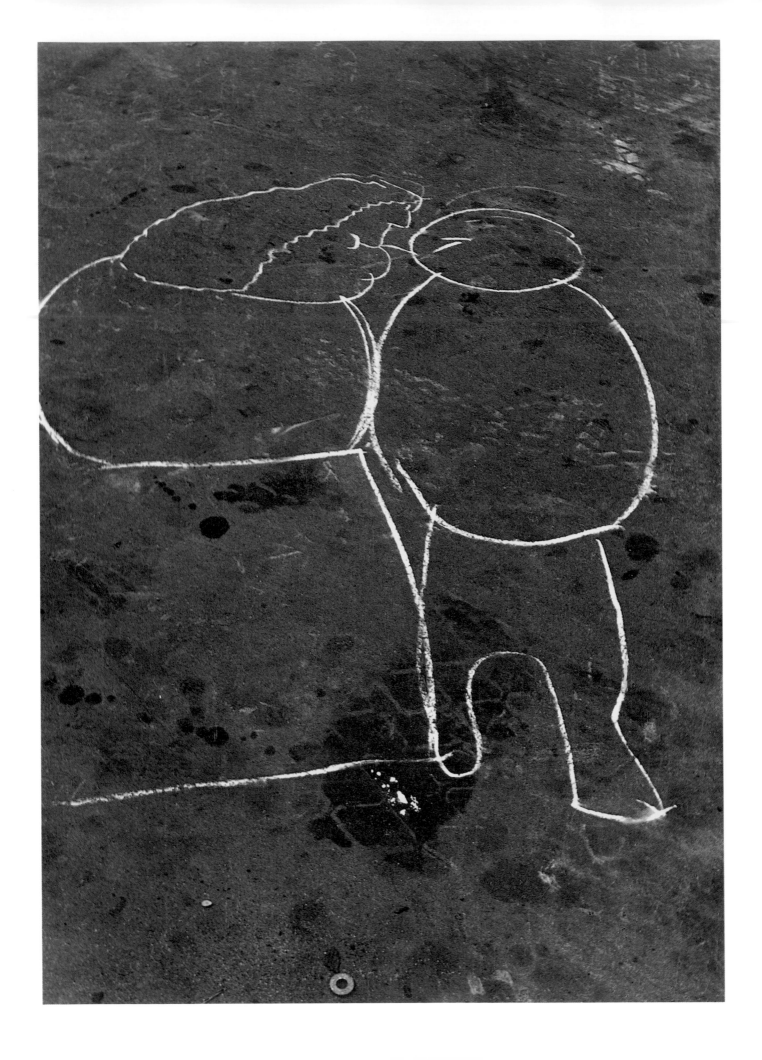

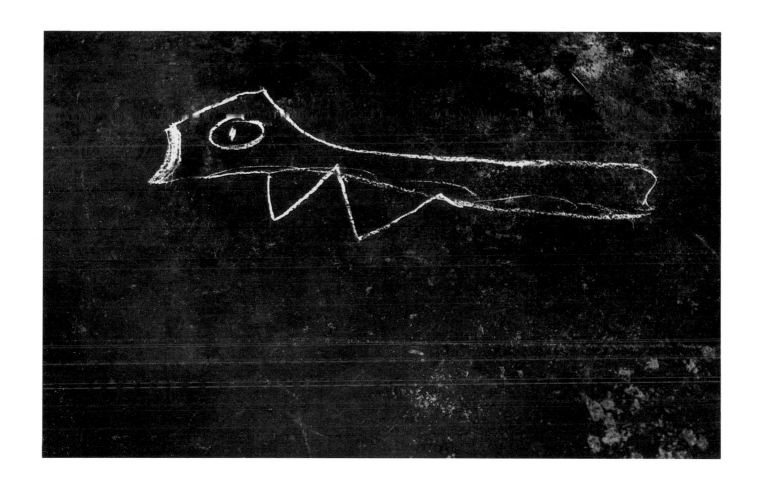

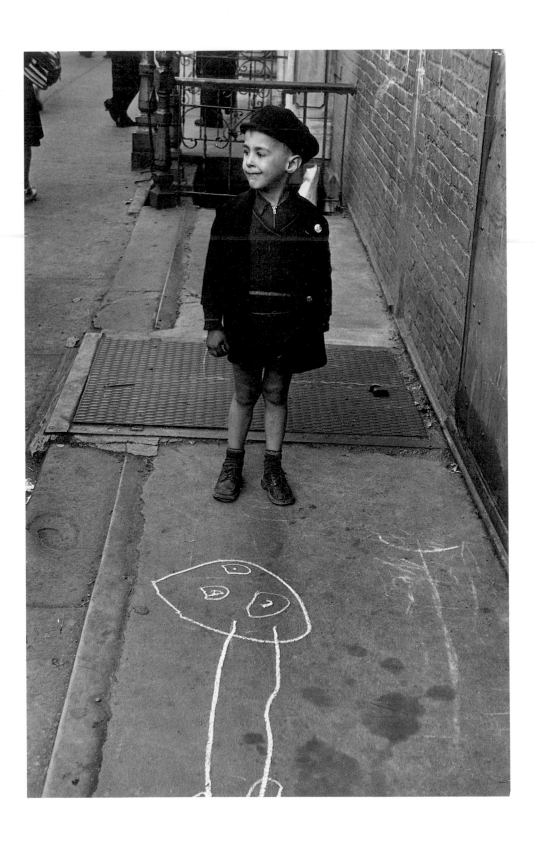

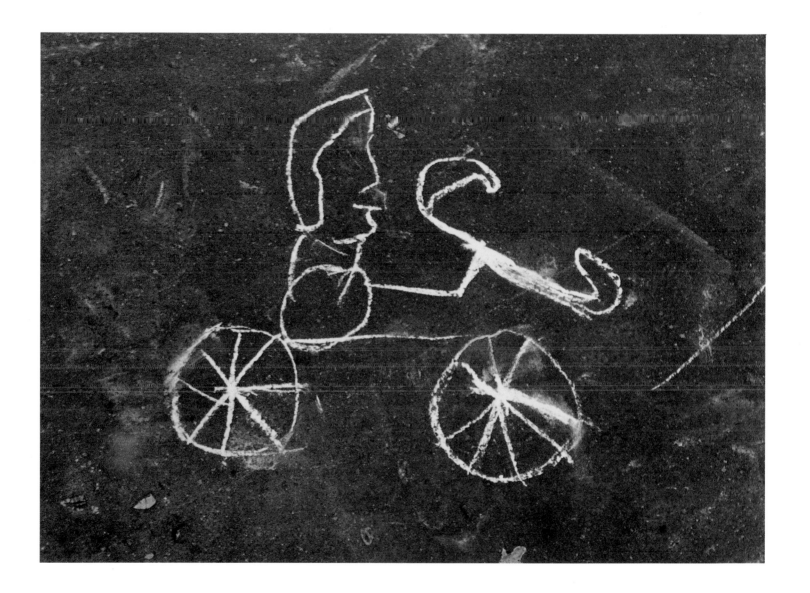

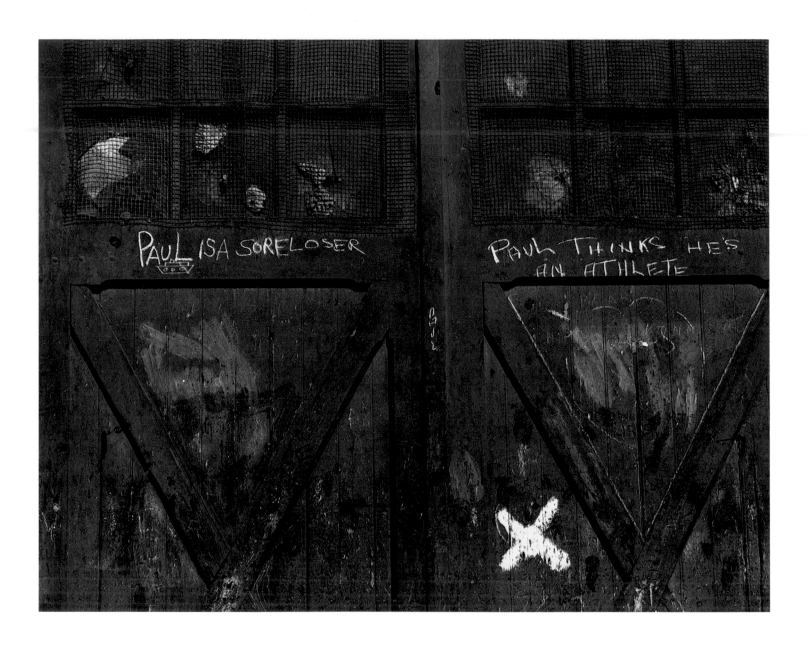

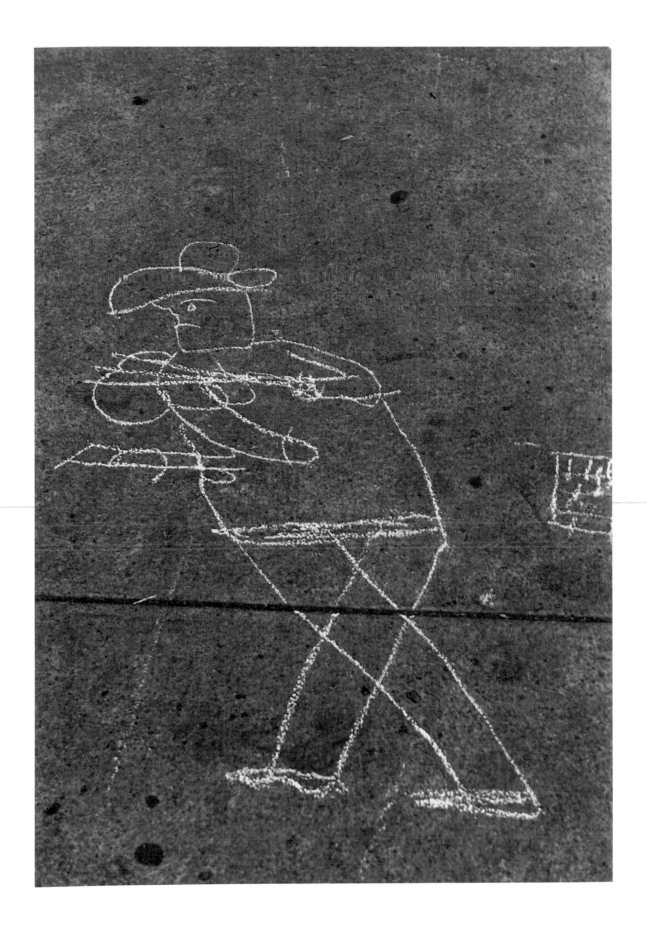

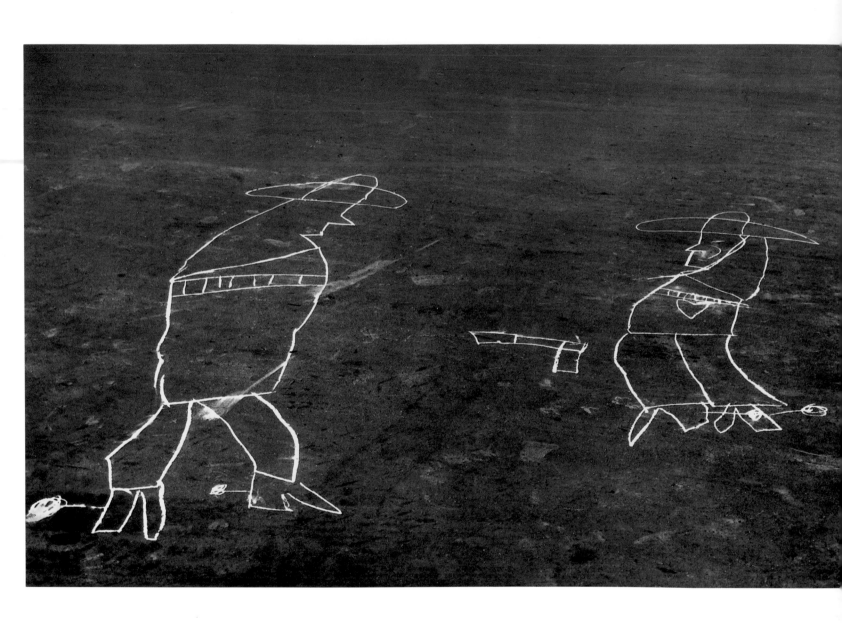

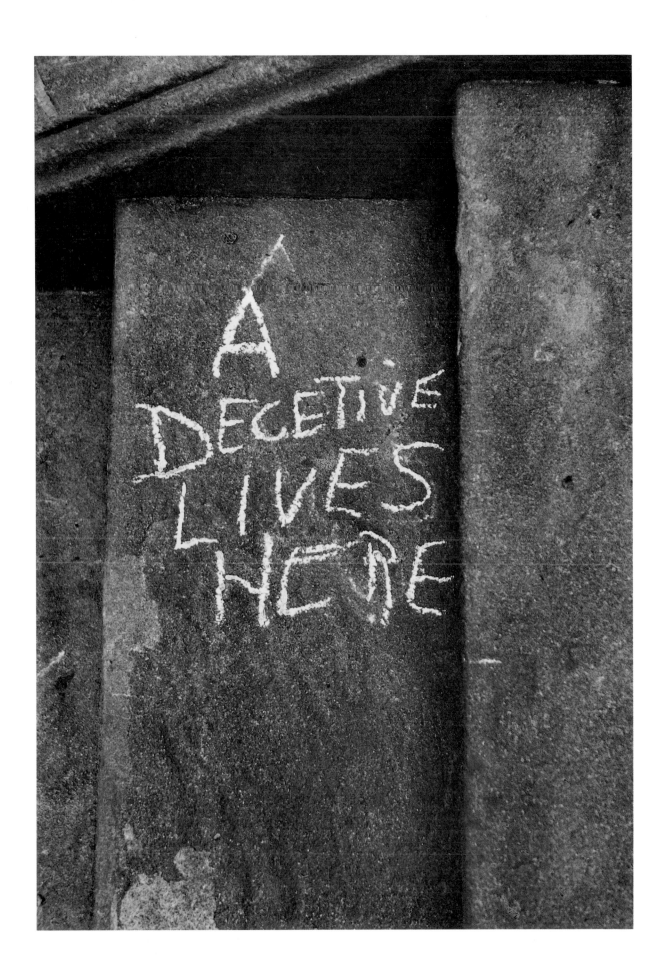

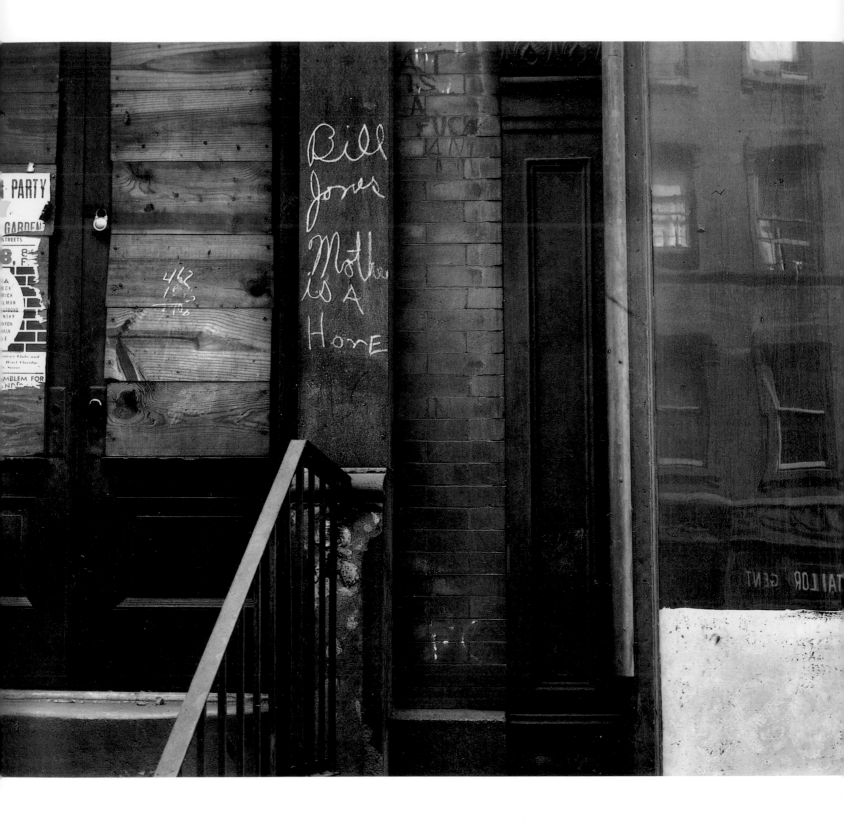

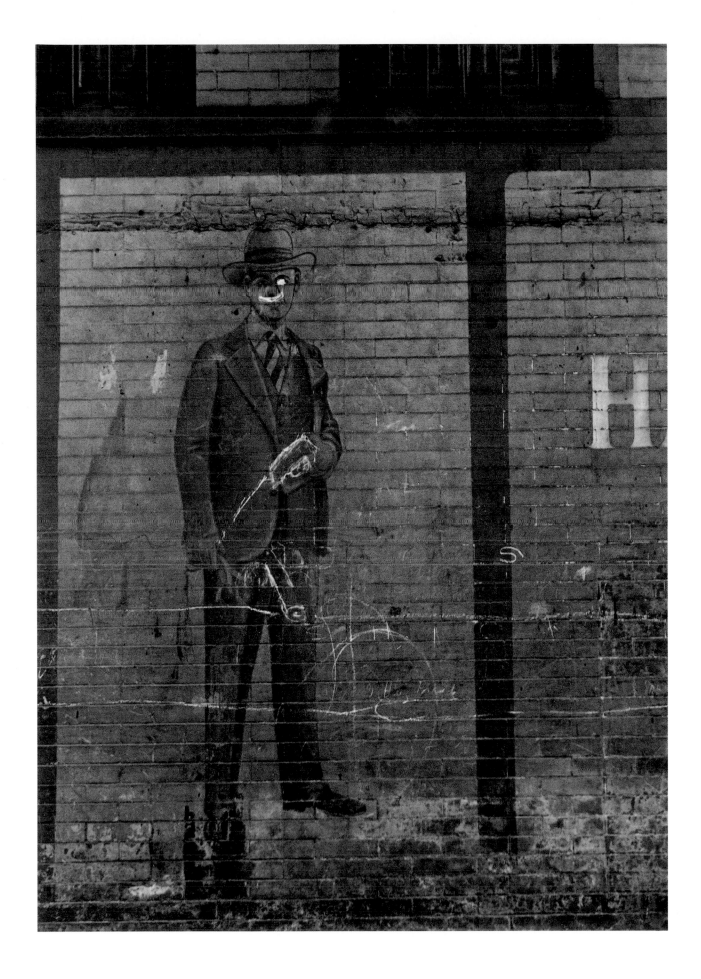

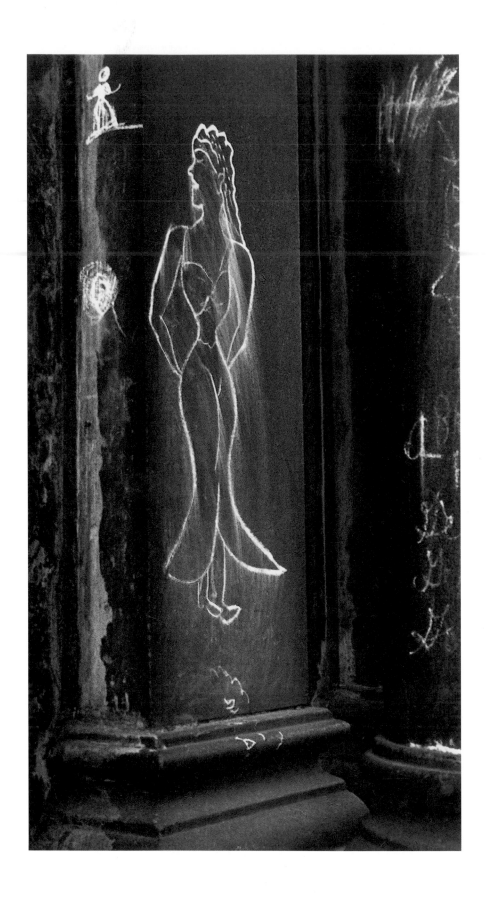

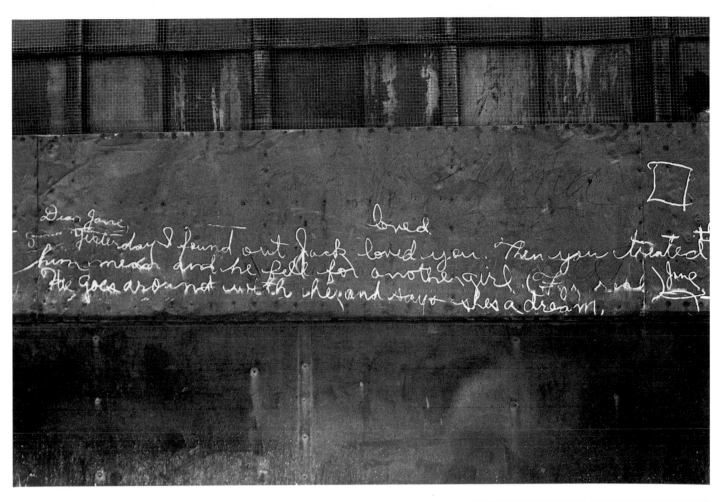

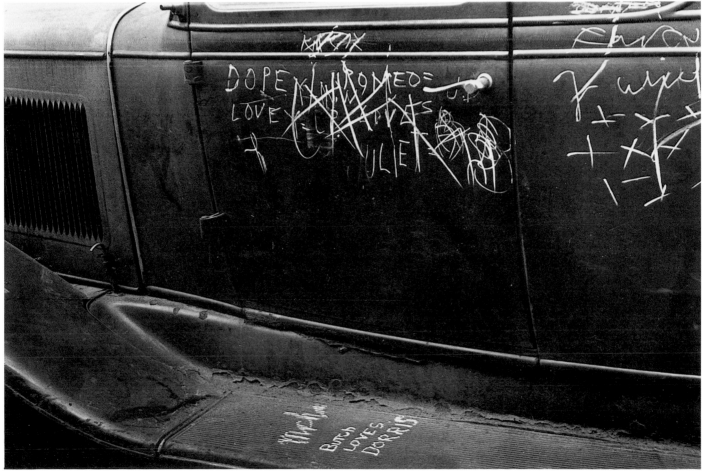

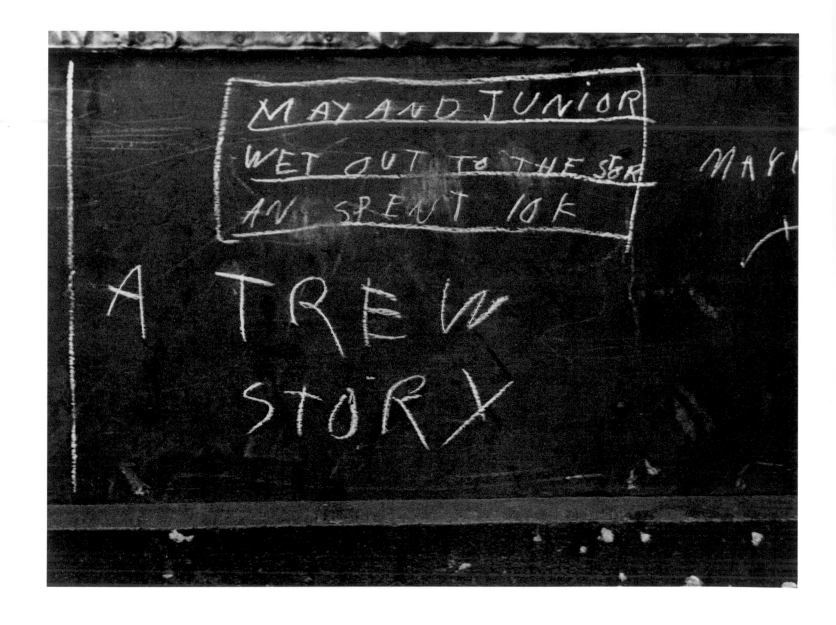

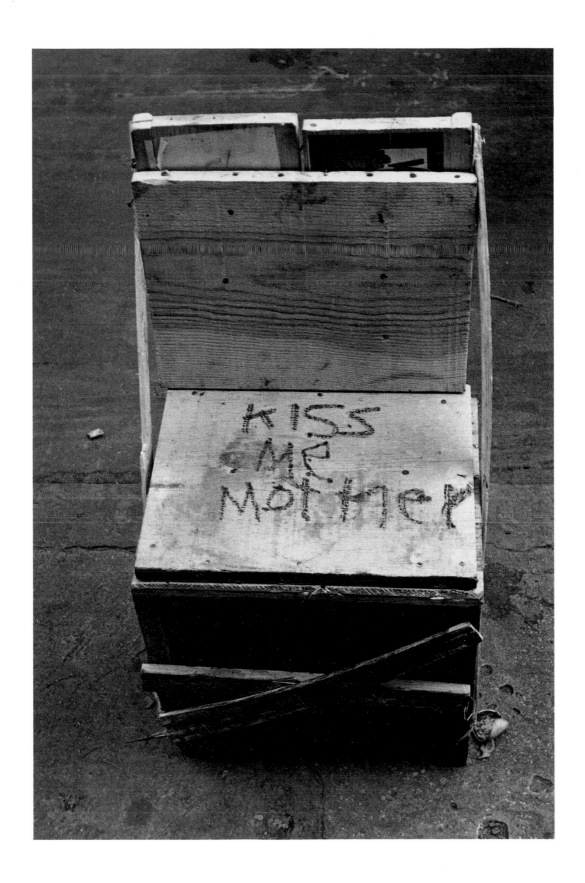

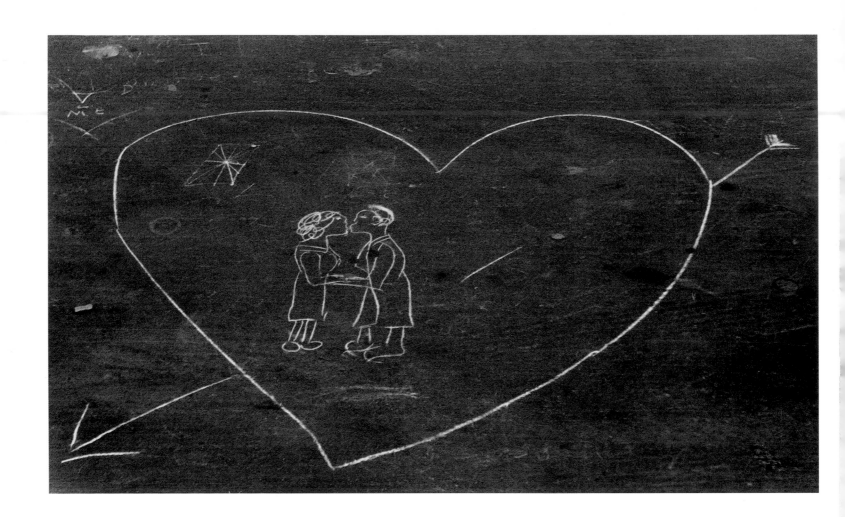

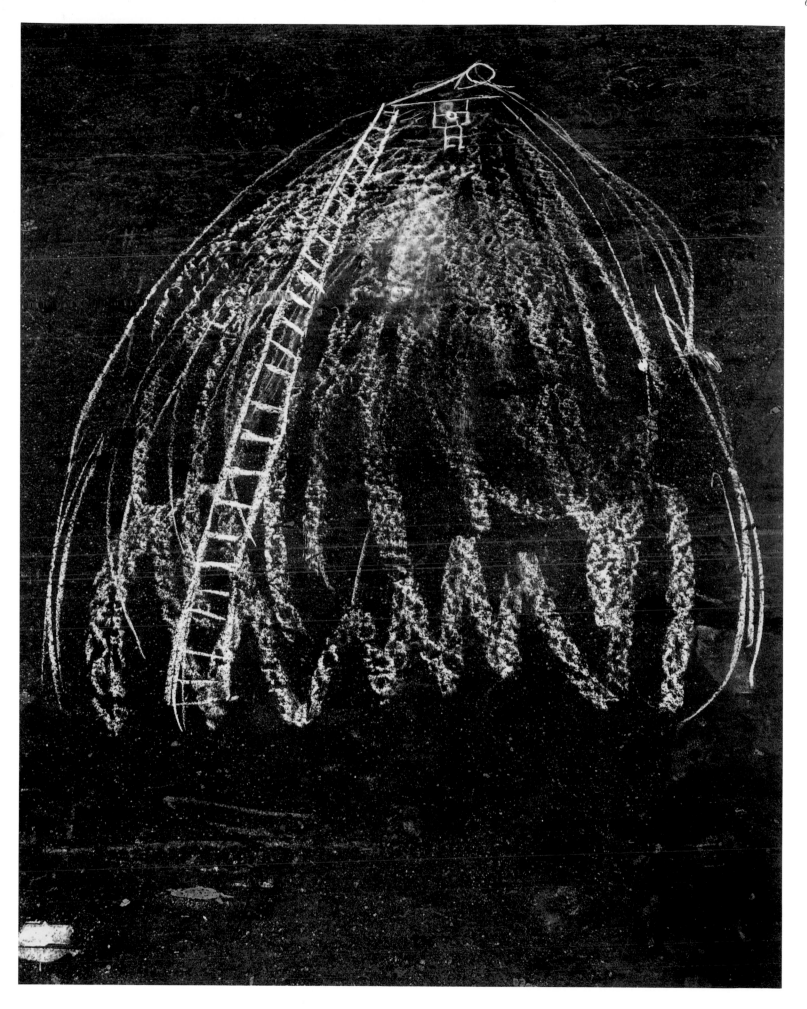

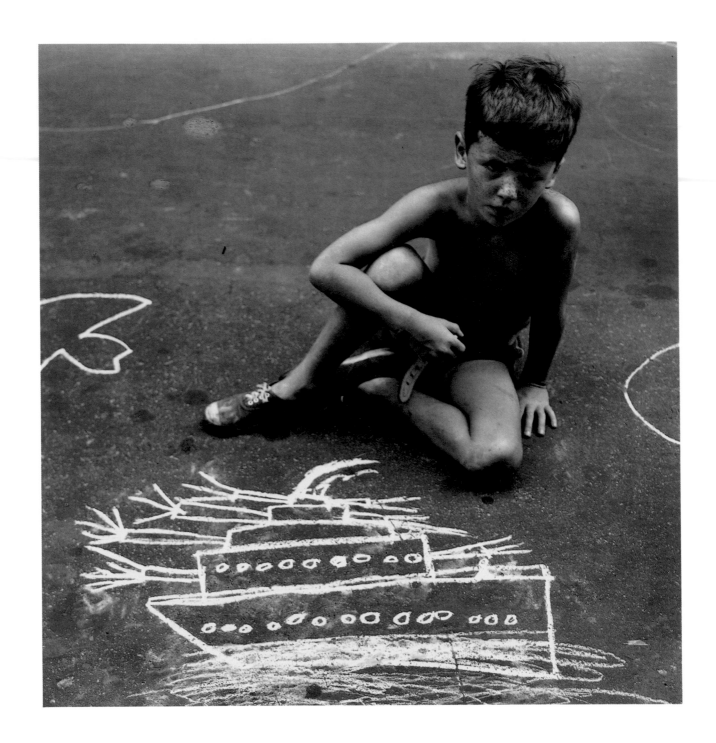

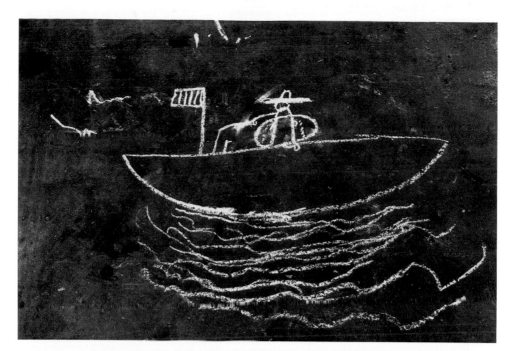

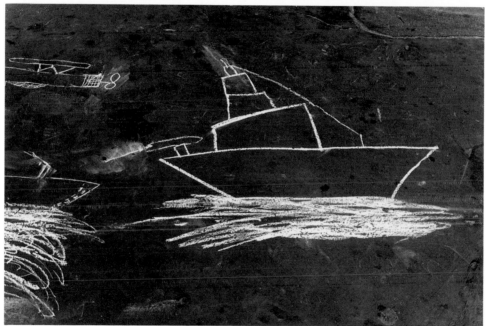

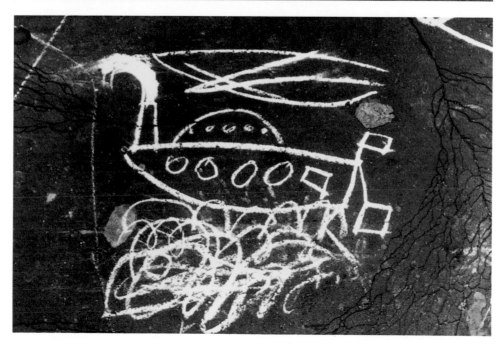

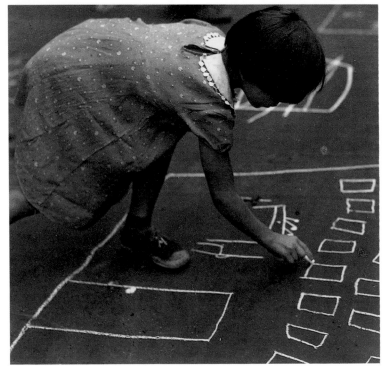

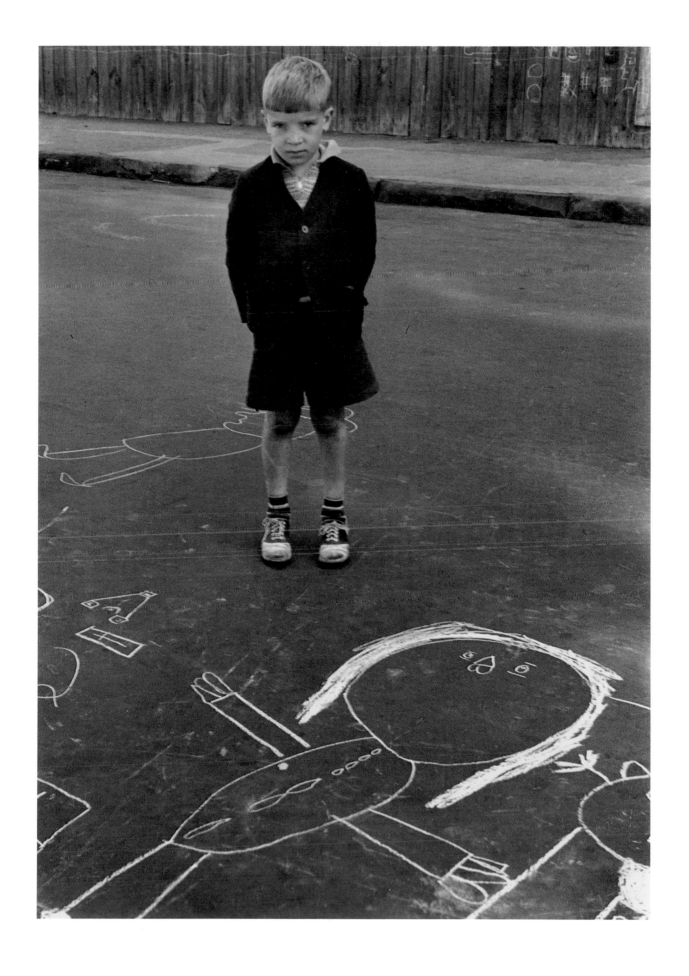

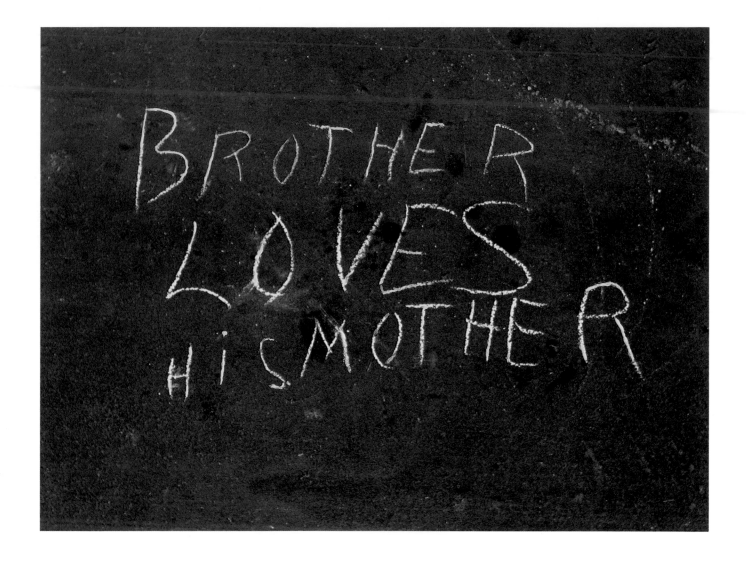

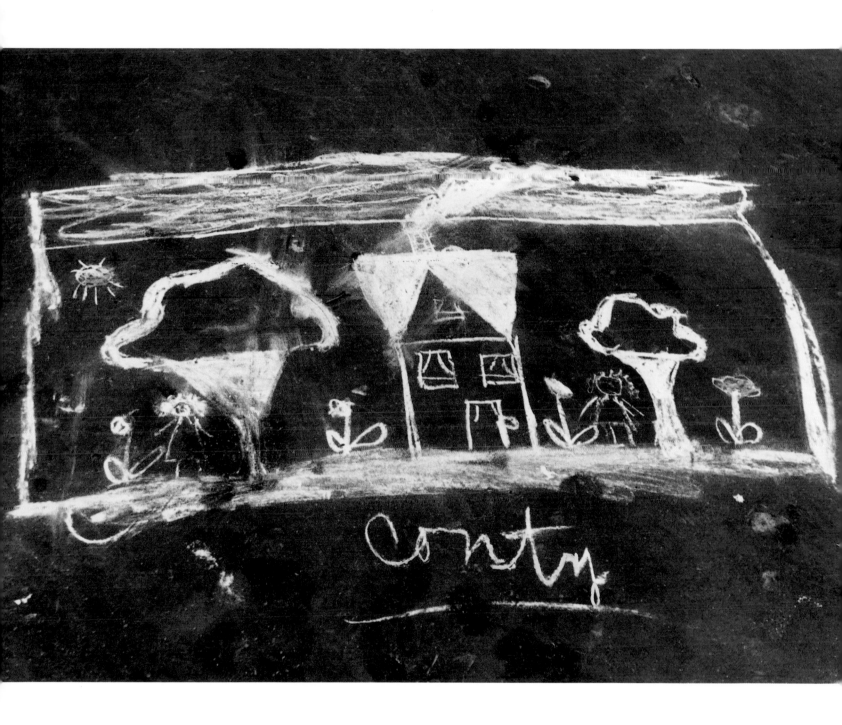

Art Center College Library
1700 Lida Street
Pasadena, CA 91103

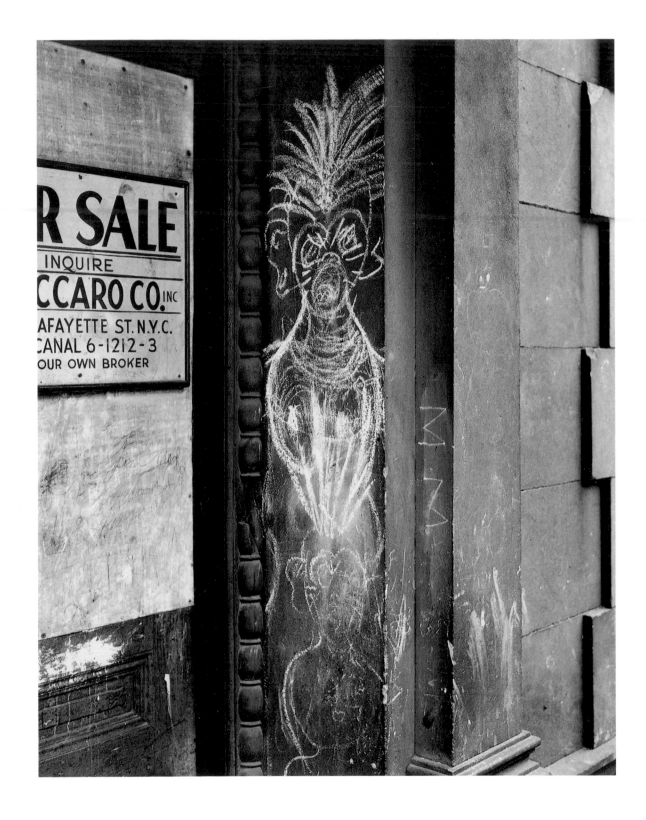

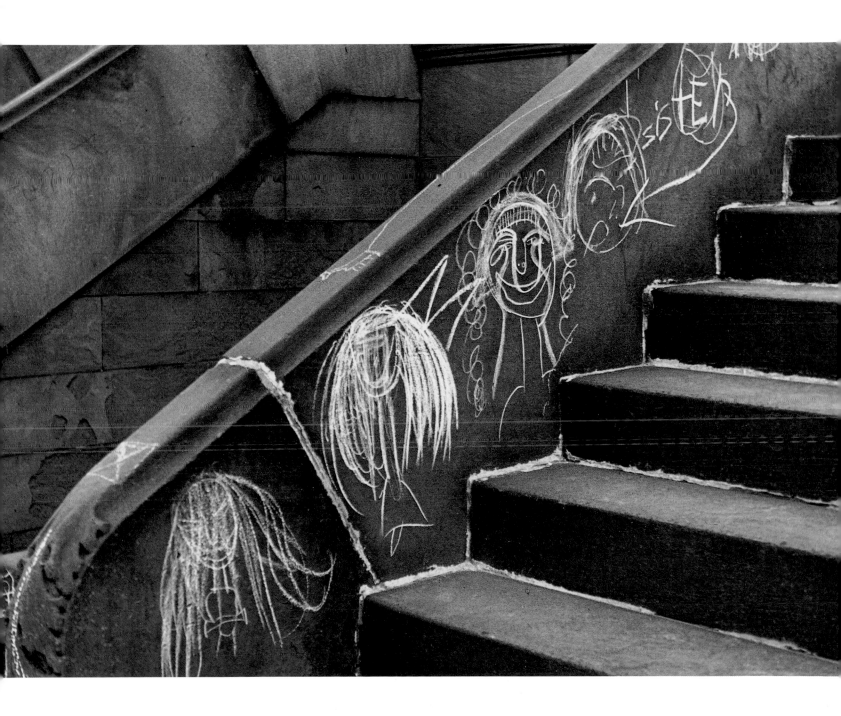

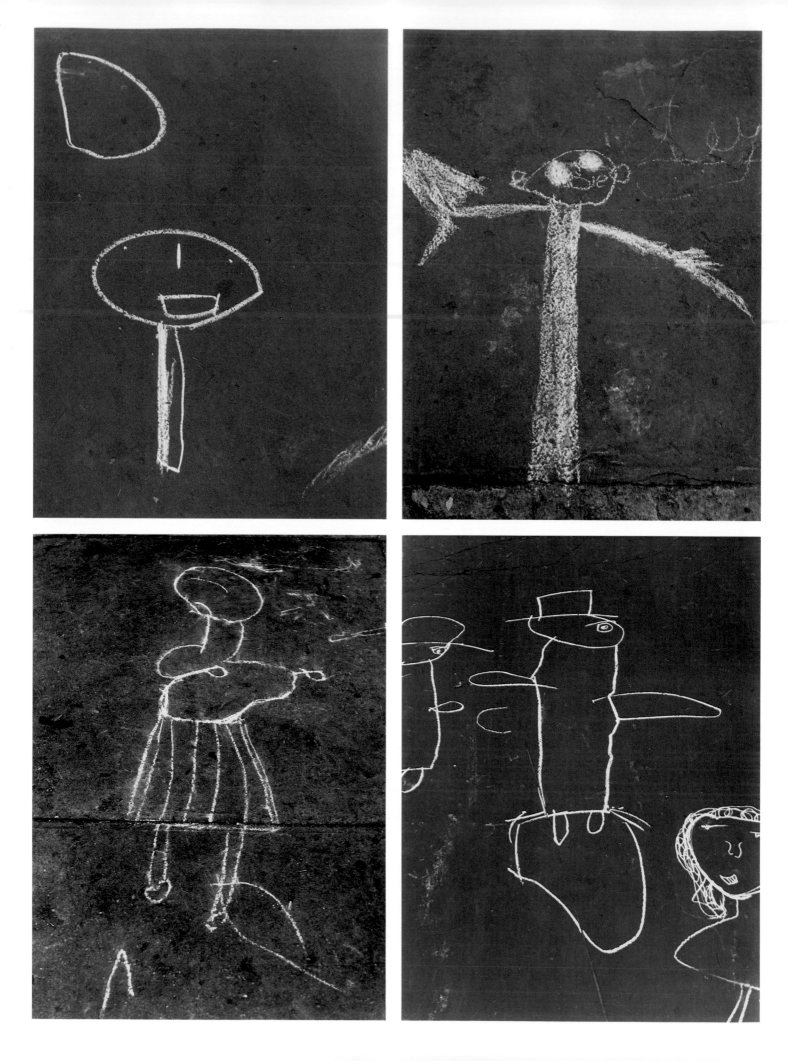

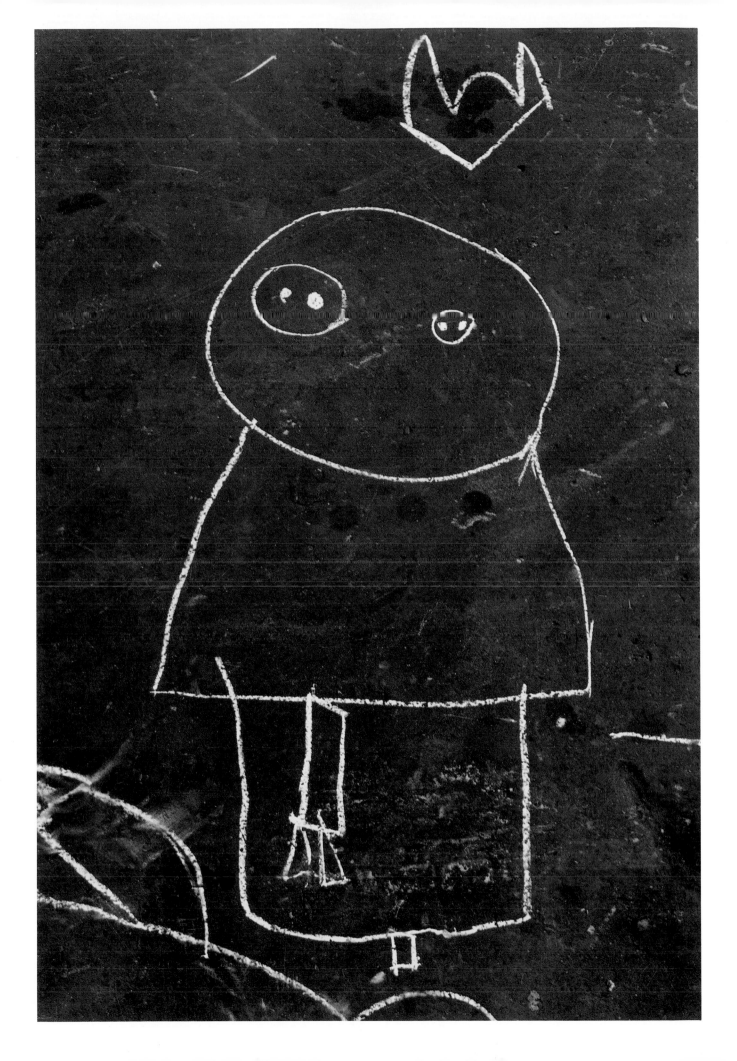

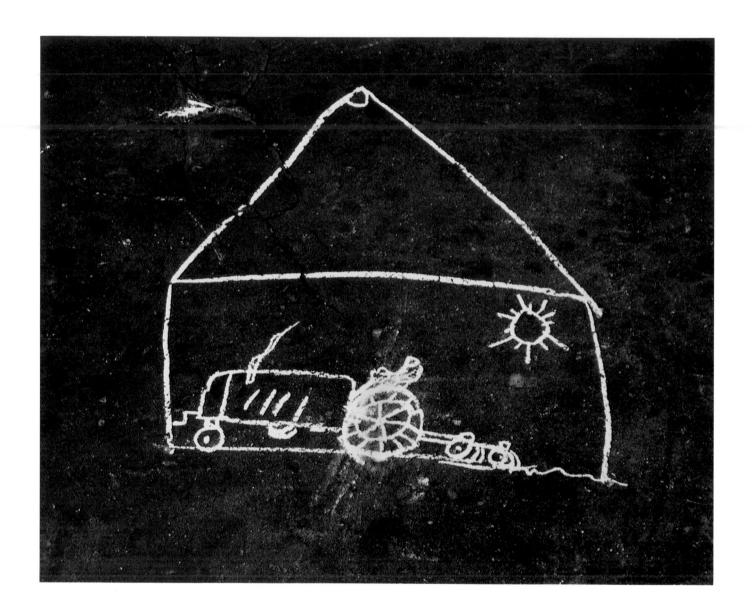

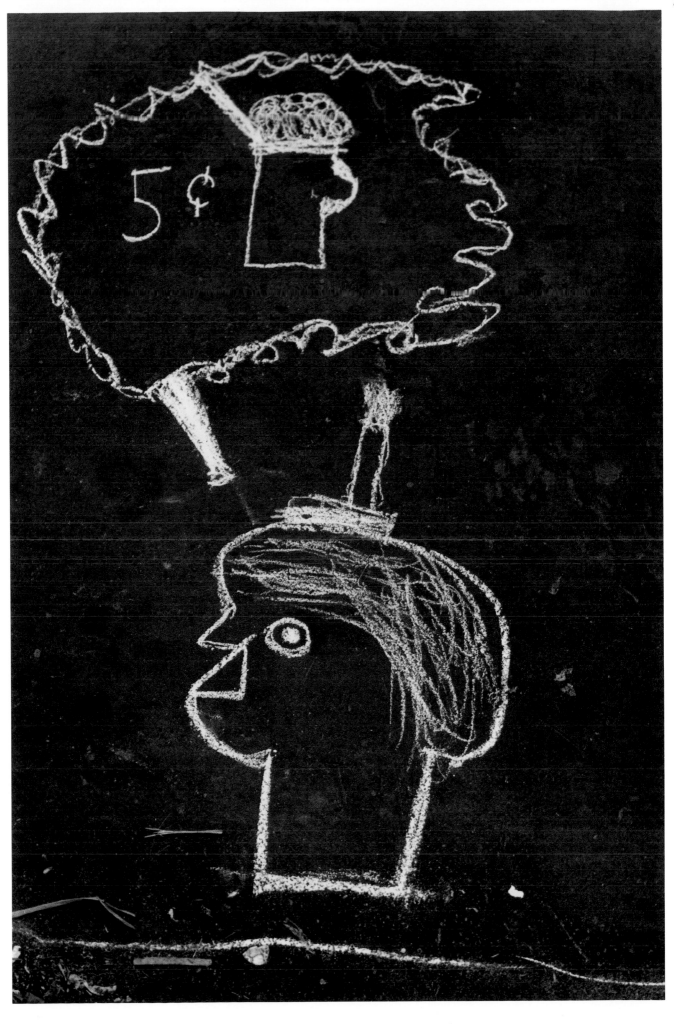

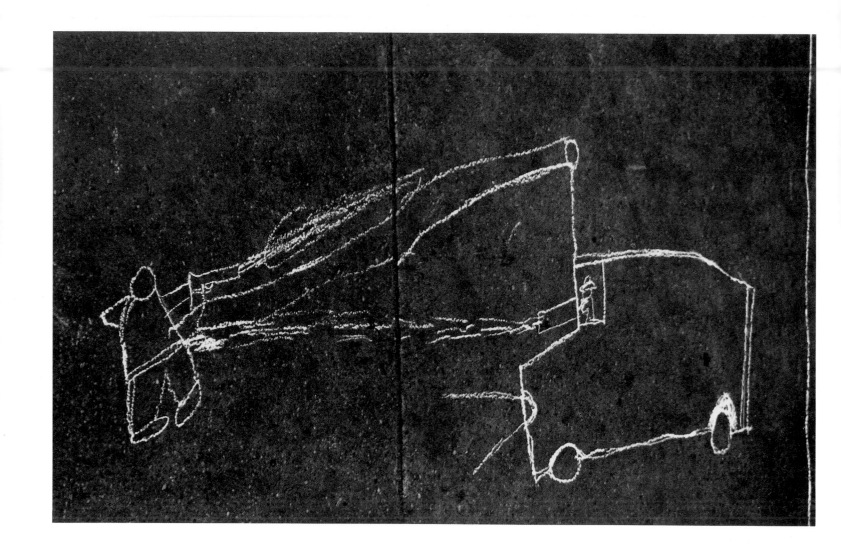

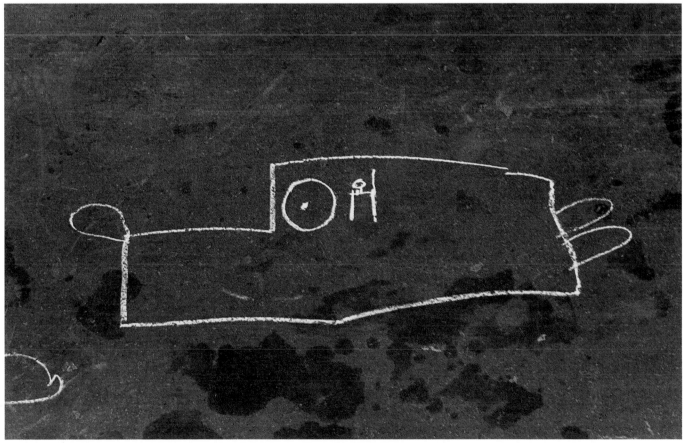

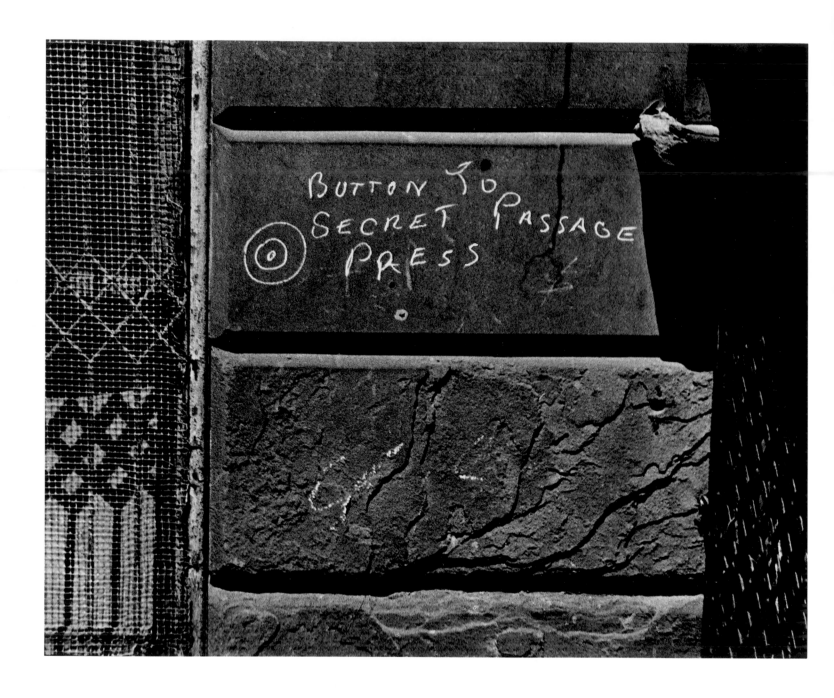

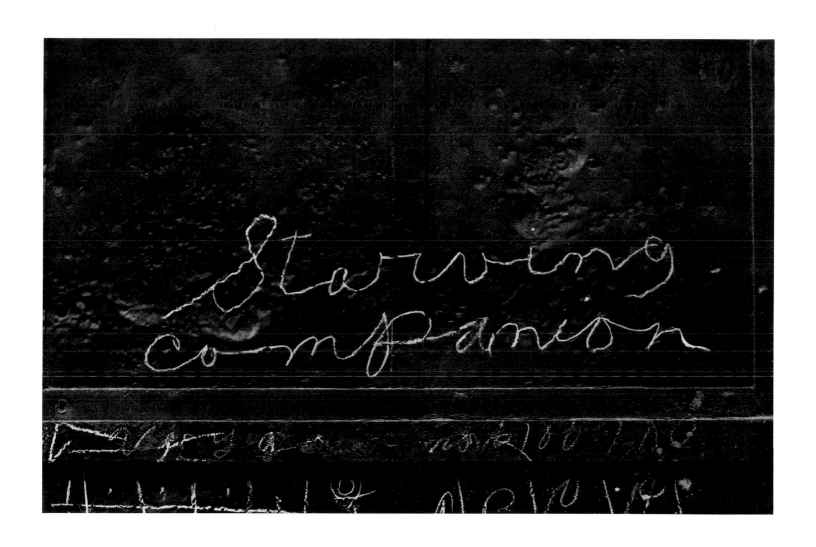

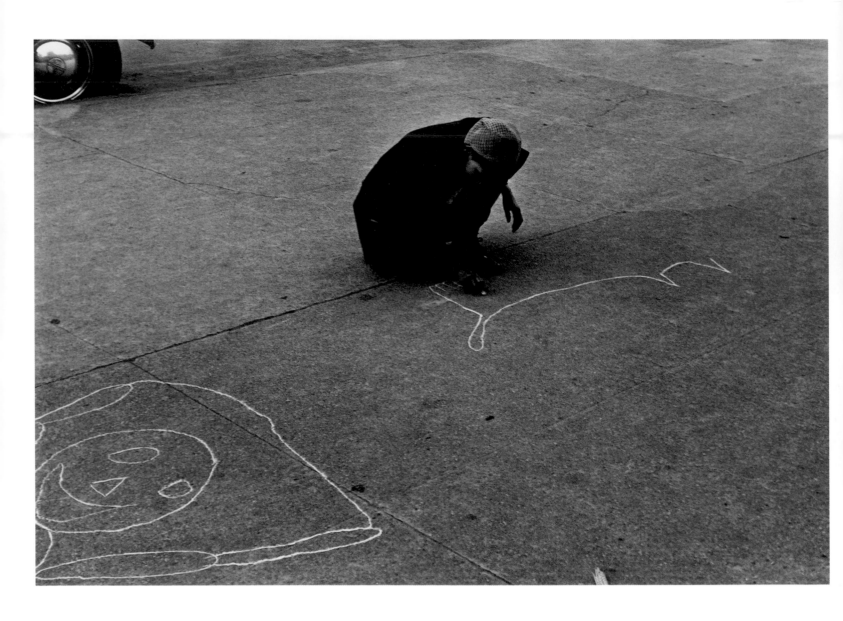

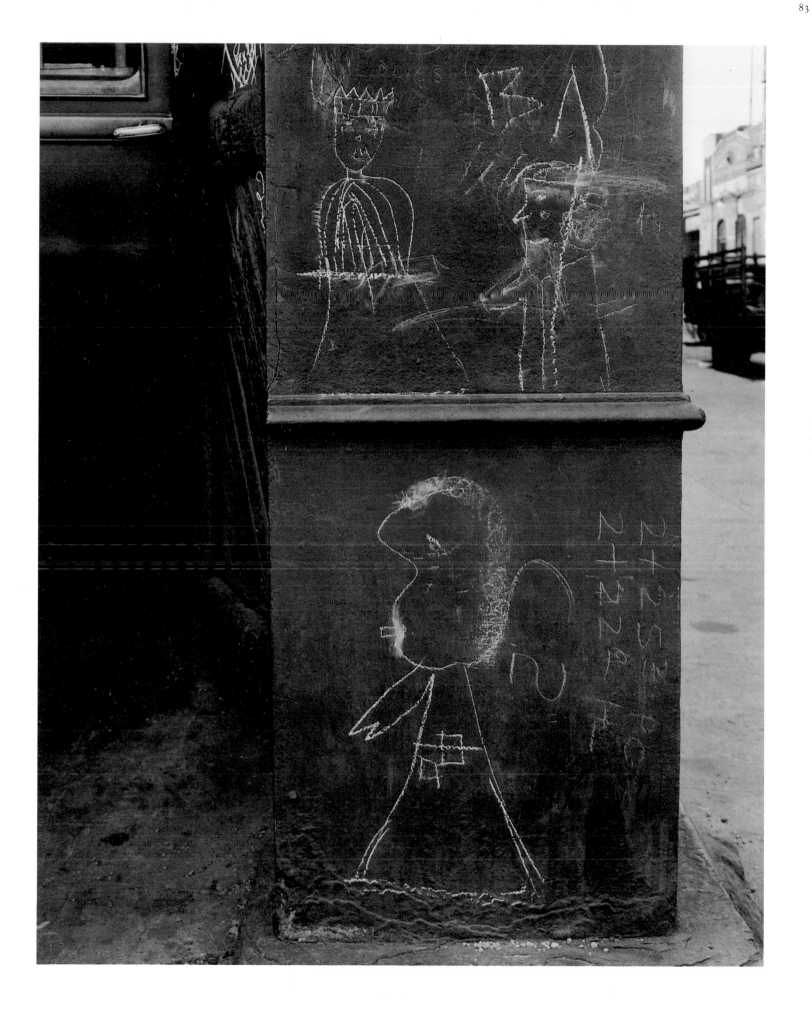

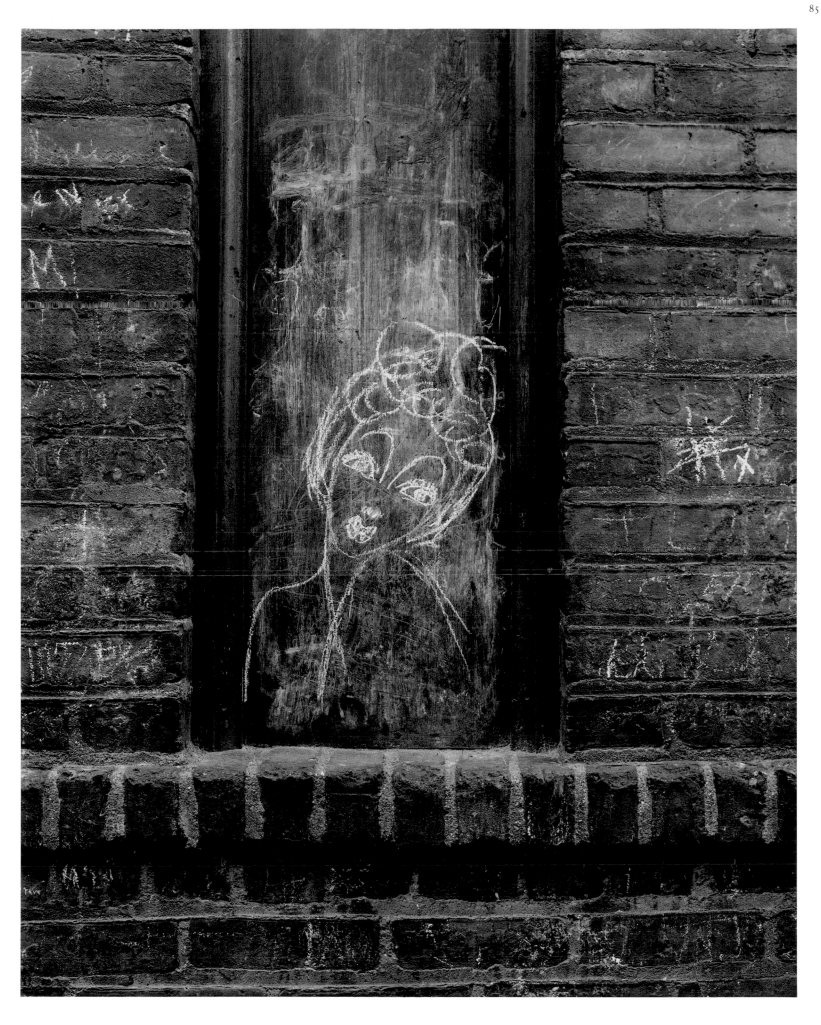

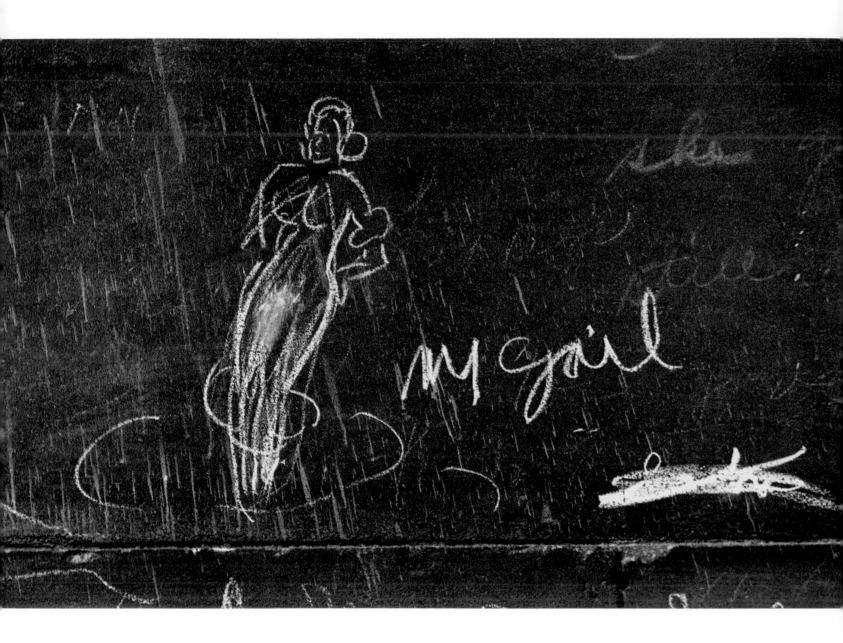

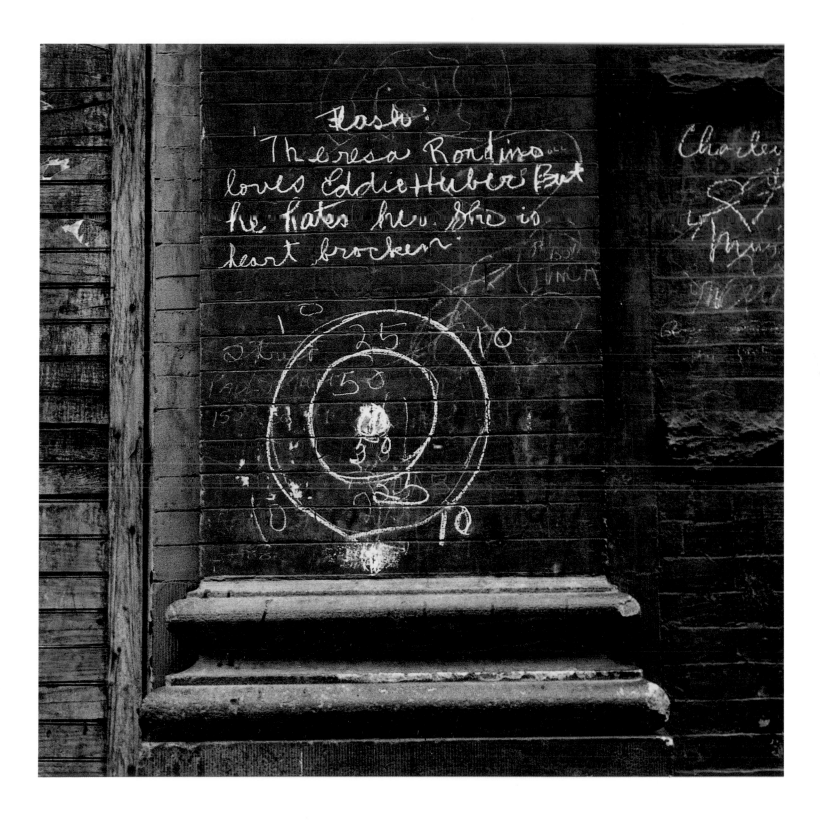

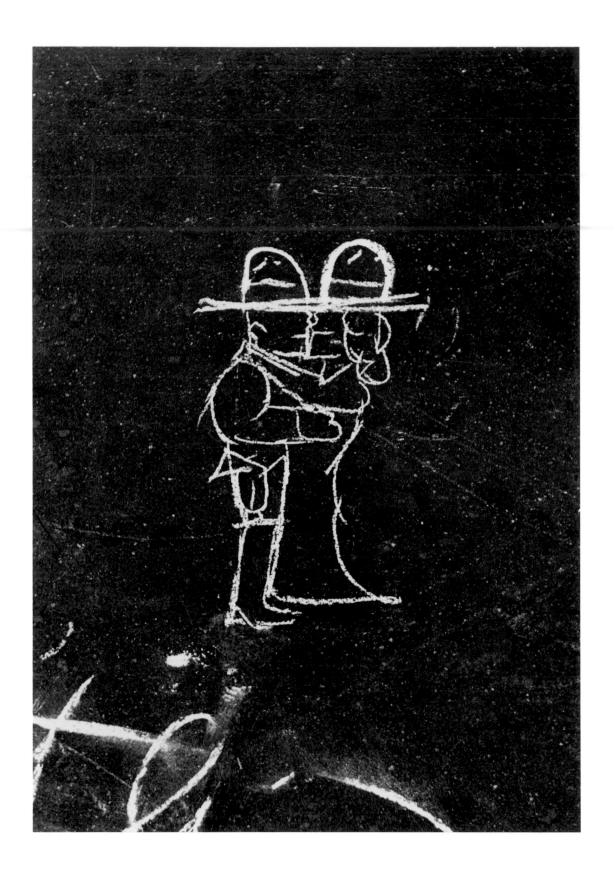

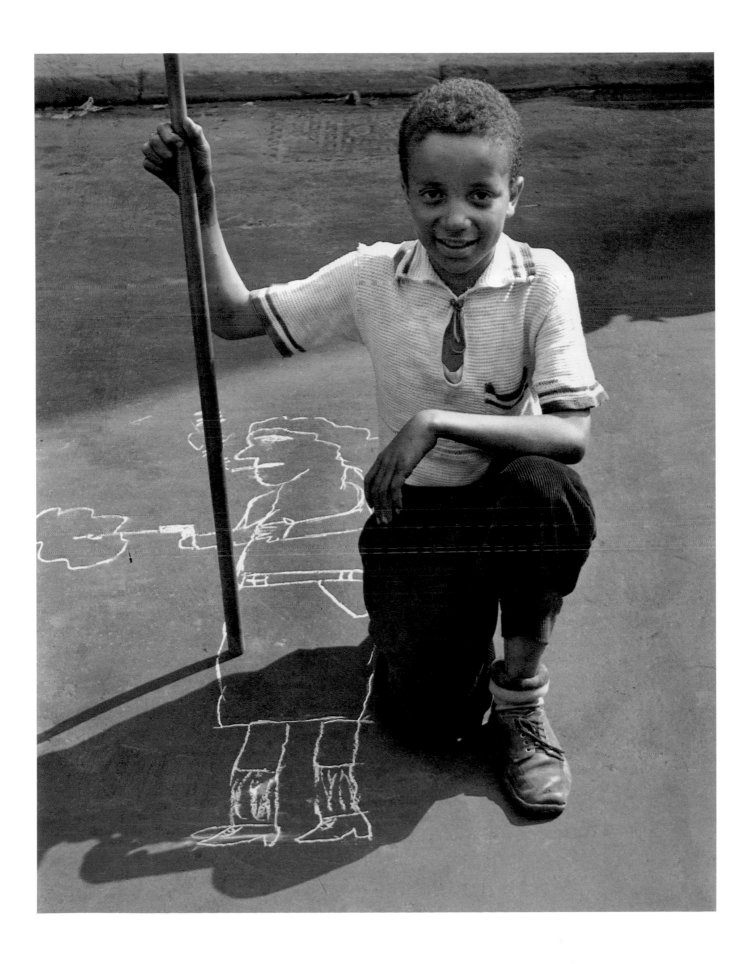

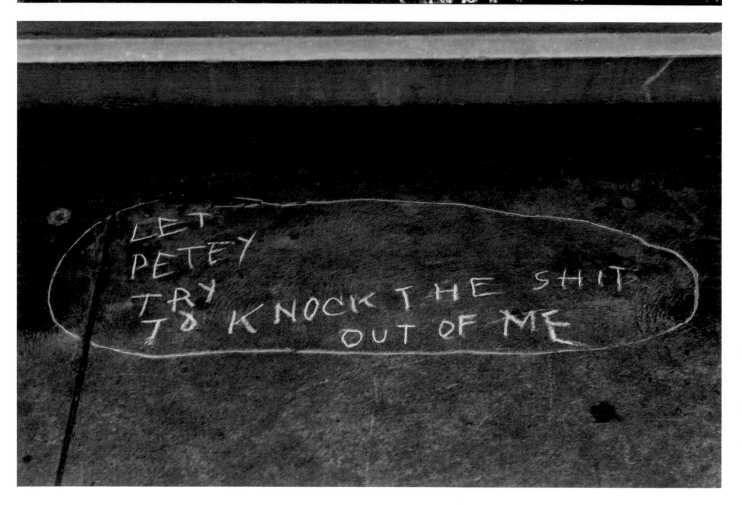

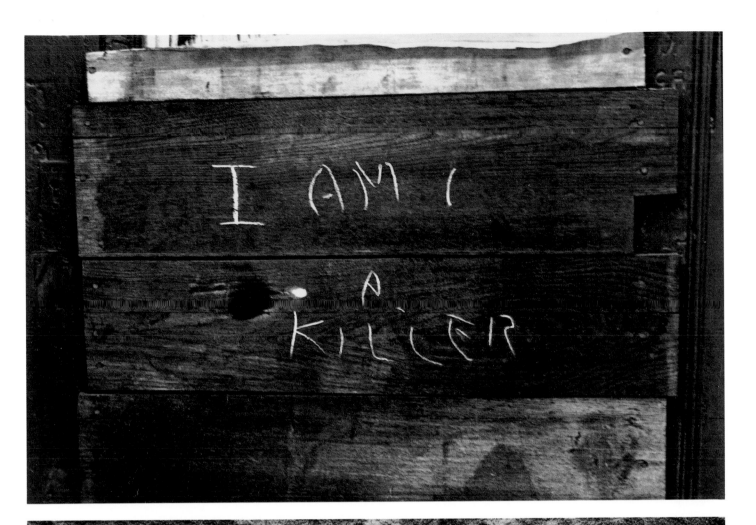

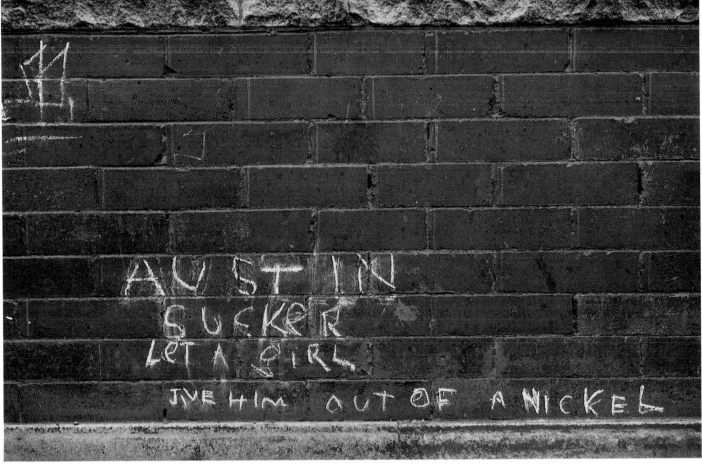

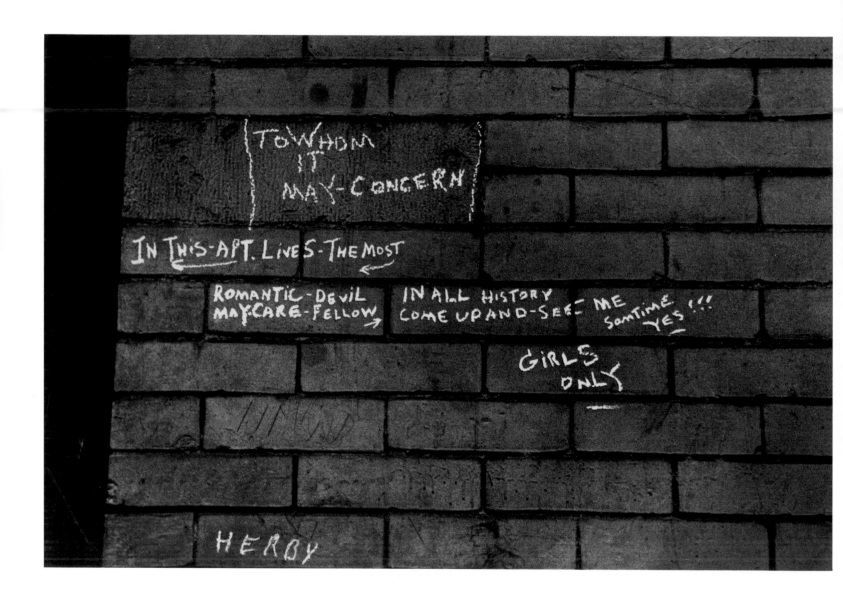

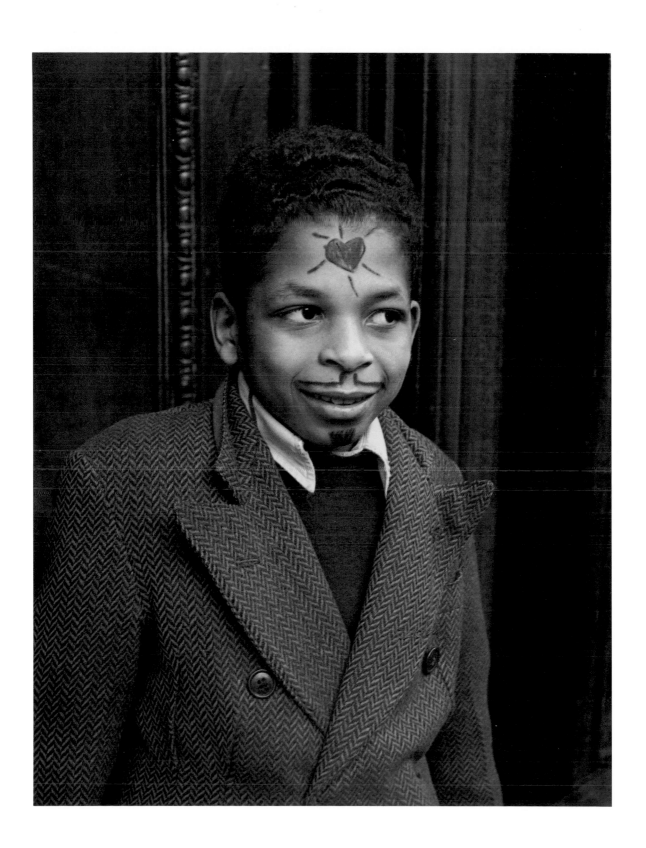

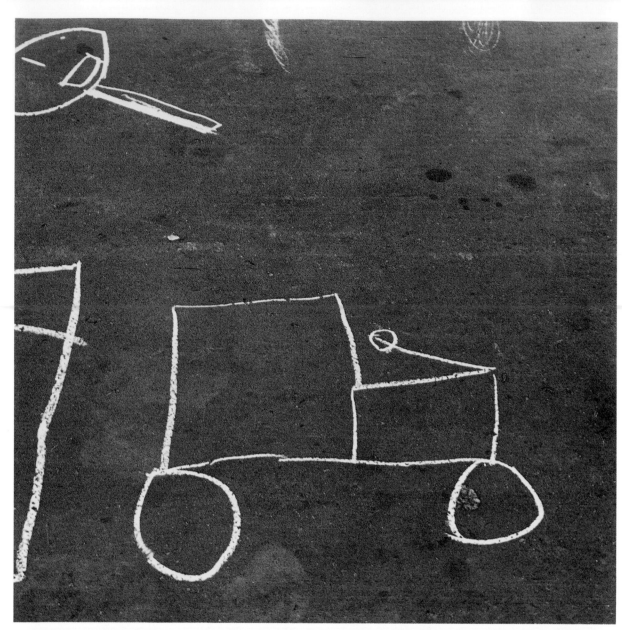

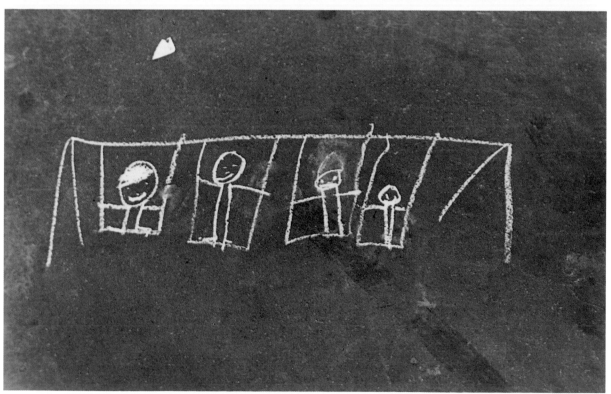

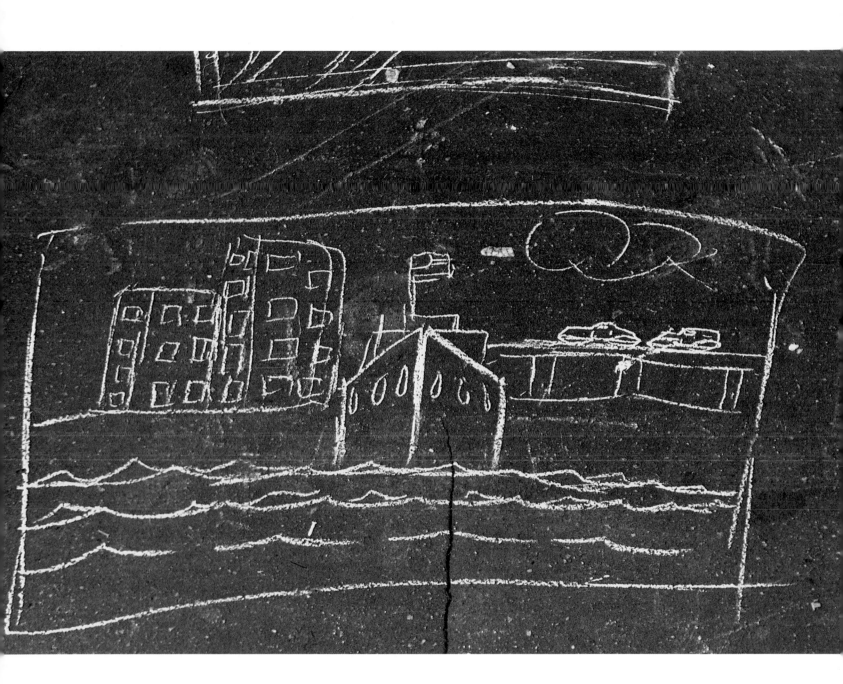

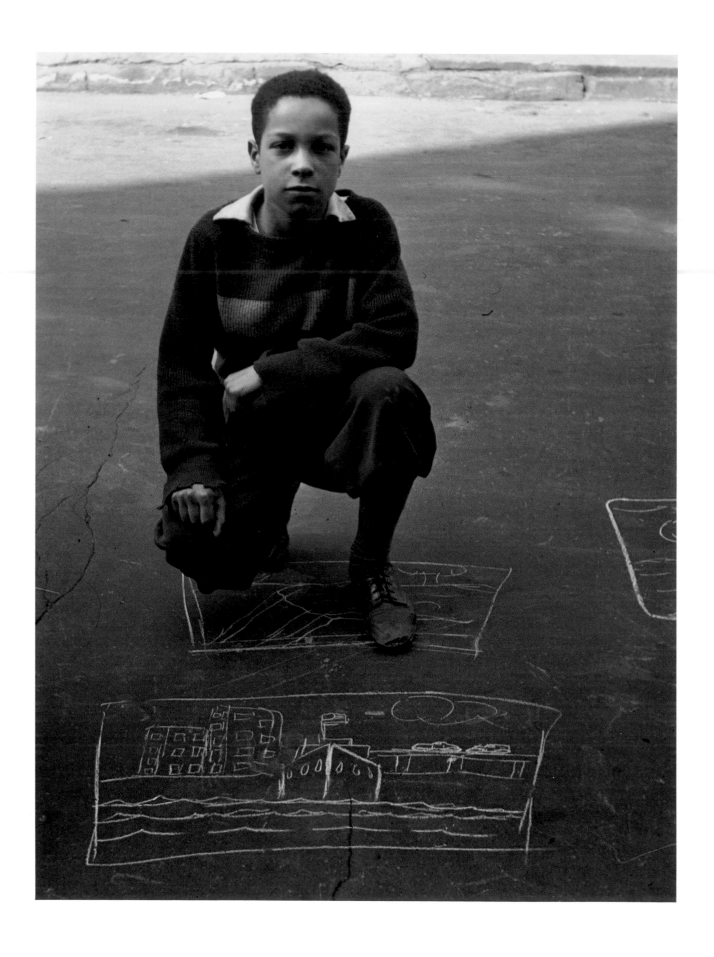

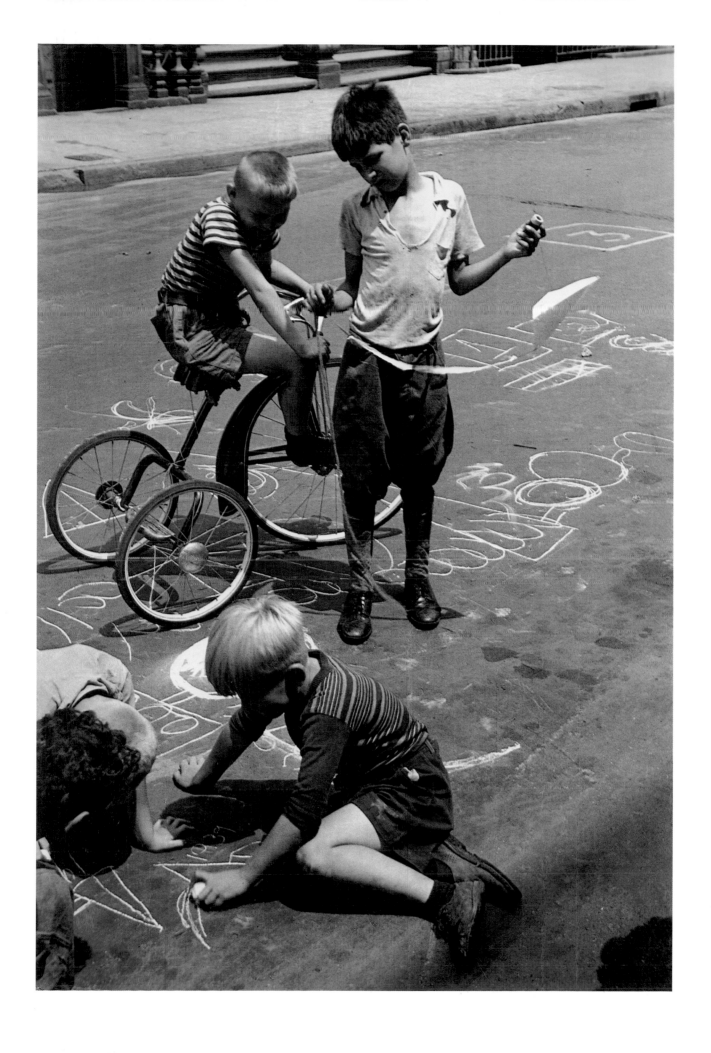

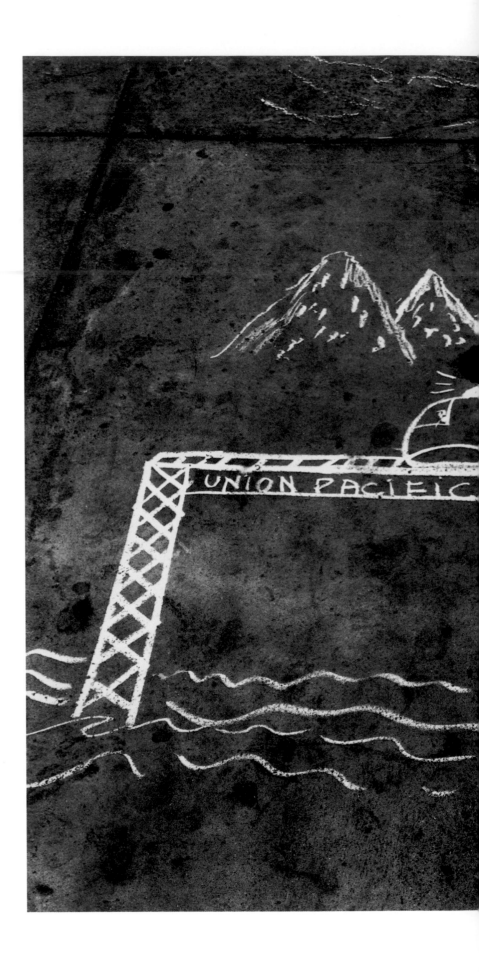

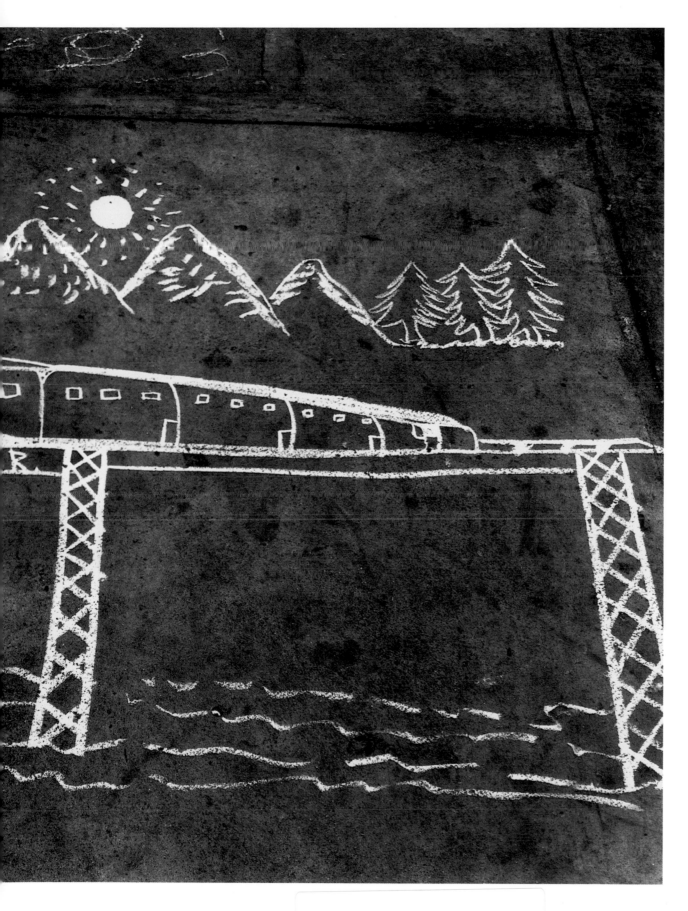

Art Center College Library
1700 Lida Street
Pasadena, CA 91103

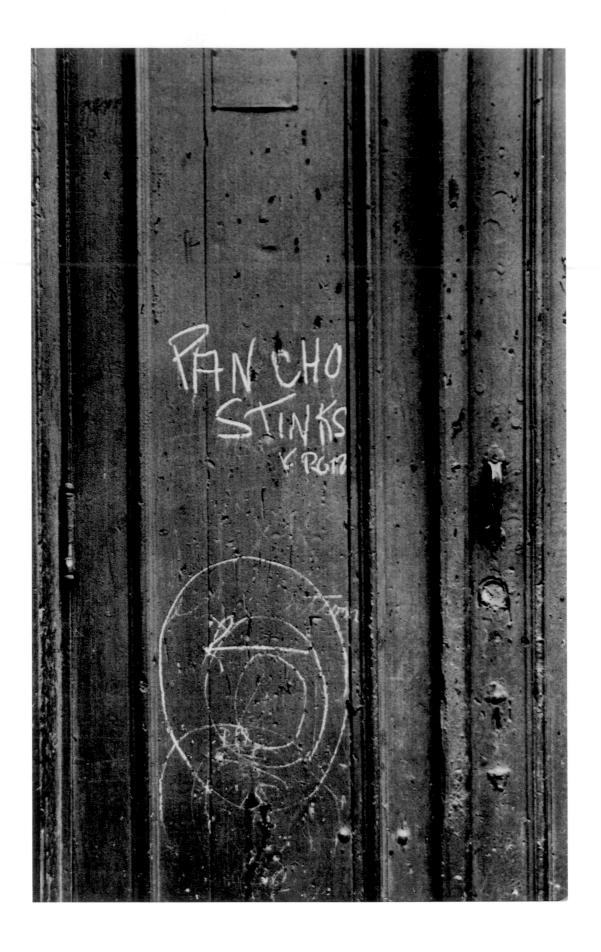

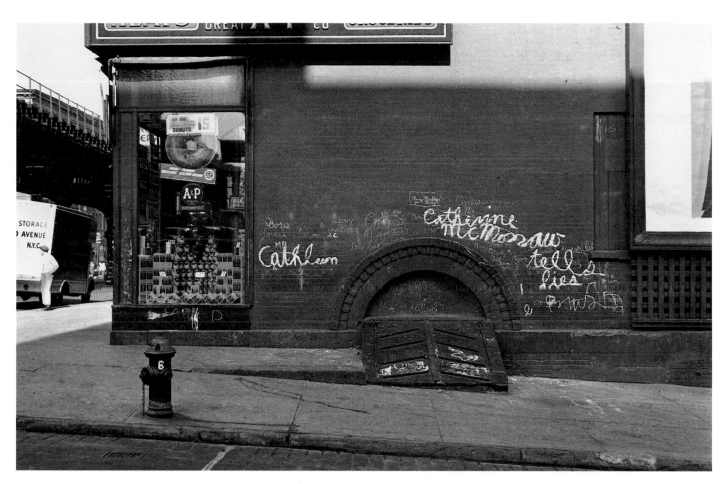

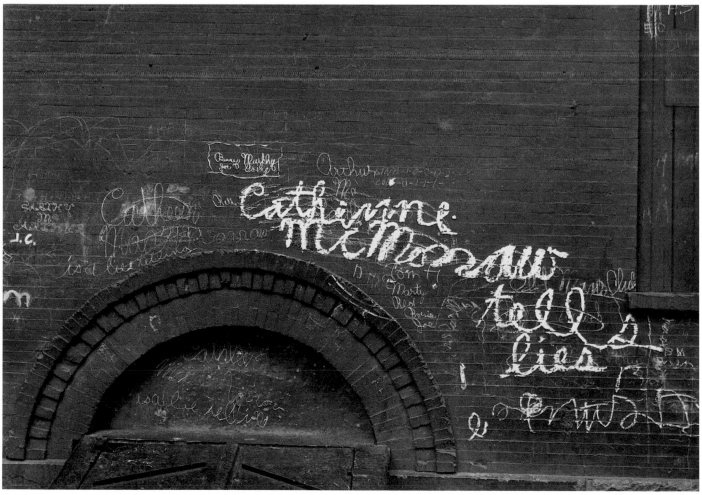

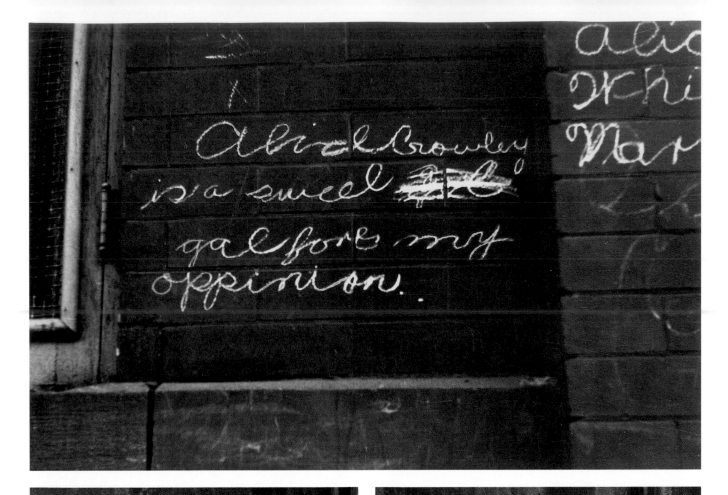

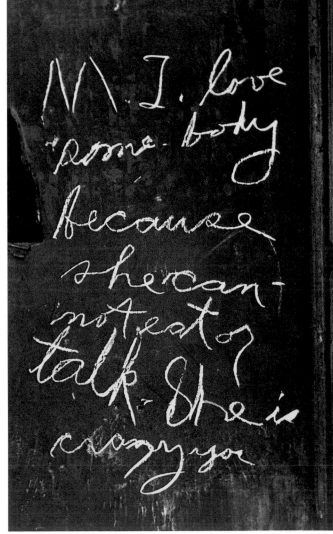

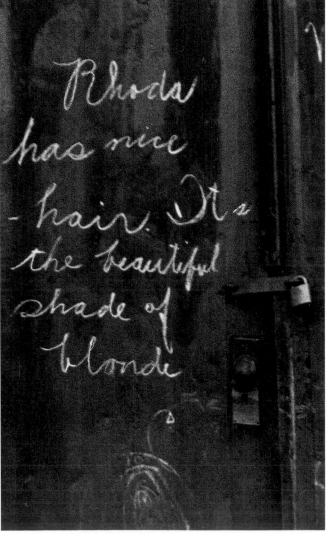

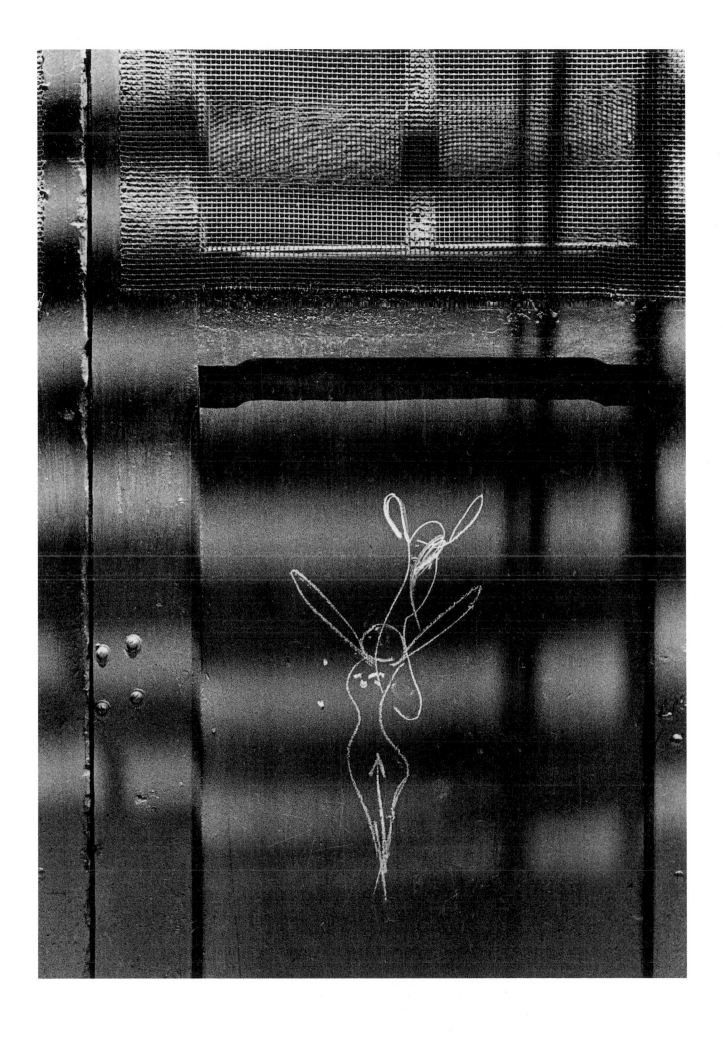

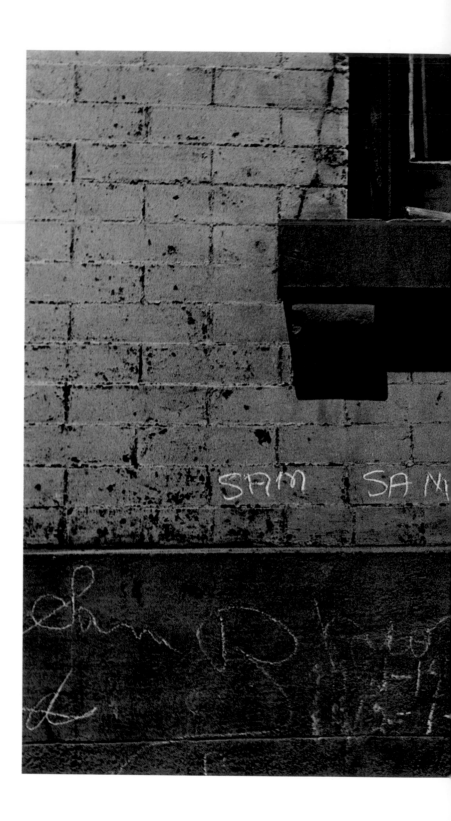

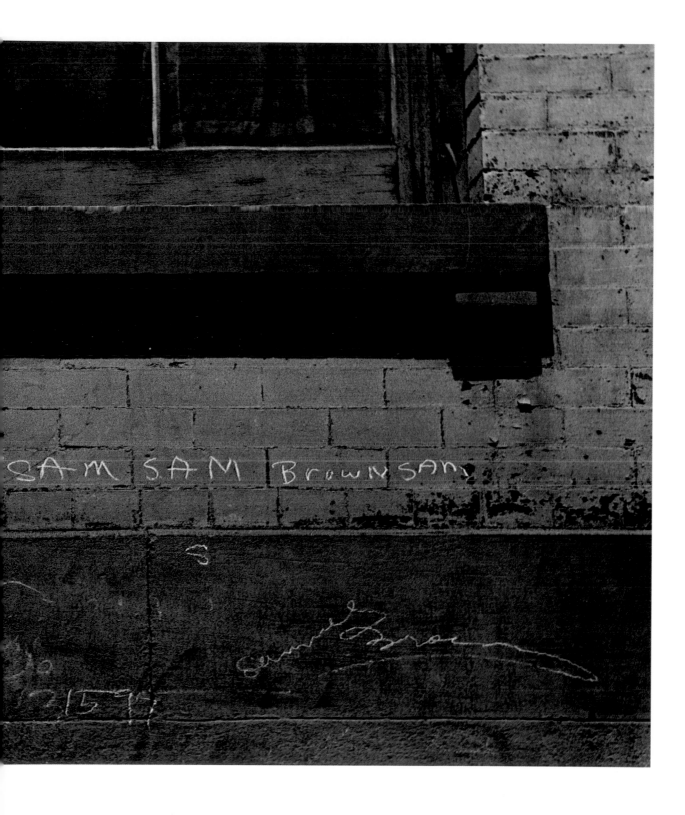

The Messages

EDITED BY ALEX HARRIS AND MARVIN HOSHINO

TYPESETTING BY G & S TYPESETTERS

PRINTED AND BOUND IN JAPAN BY TOPPAN PRINTING

DESIGN BY MARVIN HOSHINO

120630

Avalon

23.03

May 1, 2013

Art Center College Library
1700 Lida Street
Pasadena, CA 91103